D1477401

THE KYLE OF LOCHALSH LINE

EWAN CRAWFORD

AMBERLEY PUBLISHING

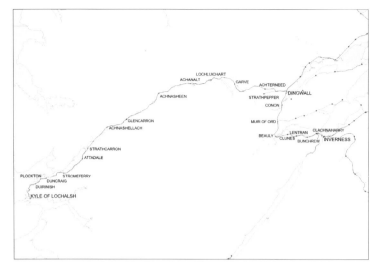

The Dingwall & Skye Railway, Strathpeffer Branch and Kyle Extension are shown running west from Dingwall on this map which includes Inverness, the starting point for trains to Kyle of Lochalsh.

Front cover, above: Lantern slide of Kyle of Lochalsh, see page 95. (*Ewan Crawford Collection*)
Front cover, below: After a lengthy pause at Achnasheen the 'Great Britain' continues east. The train is seen here at the east end of Loch a' Chuilinn midway between Achanalt and Lochluichart. (*Ewan Crawford, 26/04/2013*)
Back cover, above: A westbound 26024 pauses at Strathcarron on a tour allowing passengers time to take photographs. Note the Manson tablet catcher to the right of the locomotive. (*Glyn Weigh*)
Back cover, below: 158715 enters the rockfall tunnel near Attadale with a Kyle to Inverness service. (*Mark Bartlett, 11/07/2012*)

For James Crawford, my father, whose love of sailing ensured that my earliest memories are of the west coast: full sail in adverse weather conditions, obscure anchorages and the finest scenery.

First published 2014

Amberley Publishing
The Hill, Stroud
Gloucestershire, GL5 4EP

www.amberley-books.com

Copyright © Ewan Crawford, 2014

The right of Ewan Crawford to be identified as the Author of this work has been asserted in accordance with the Copyrights, Designs and Patents Act 1988.

ISBN 978 1 4456 1411 3 (PRINT)
ISBN 978 1 4456 1425 0 (EBOOK)

British Library Cataloguing in Publication Data.
A catalogue record for this book is available from the British Library.

Typeset in 9.5pt on 12pt Celeste.
Typesetting by Amberley Publishing.
Printed in the UK.

Introduction

The Dingwall & Skye Railway was the first line in the Highlands to connect the Atlantic seaboard of Scotland to the railway network. It remains open today, carrying passengers through an area of low population, moorland, inland and sea lochs and mountains. Kyle is a popular destination for rail tours and tourists in the summer months. Little freight is carried today; there are no regular workings.

In the west the terminus at Stromeferry (later replaced by Kyle of Lochalsh) served as a railhead for ferry services to Skye and the Outer Hebrides and in the east a connection is made with the railway network at Dingwall.

The line's survival is perhaps surprising: the route bypasses the only town near the line, the one area only the railway served now has a road, ferries no longer operate a regular service from the terminus pier and a road bridge has opened to Skye. But the line still does what it has always done: it provides comfortable travel through a remote and beautiful area.

With today's road network it is difficult to imagine how difficult travel was in the west of the country before the railway opened. Roads were fragmented, with ferries connecting portions together. To the south of Kyle of Lochalsh there was the Airds ferry (connecting Dornie and Ardelve), Kyle barely existed and roads from Ardelve ran to Duirinish, Plockton and the Strome Ferry. The first major road in the area was the military road from Fort Augustus to Kylerhea (Bernera Barracks) which took a similar route to earlier drove roads from Skye. Kyle was not on this road nor was it a port for Skye for travellers from the south as two ferry crossings were required while via Kylerhea there was just one. The interior away from the coast was difficult to develop and to this day there are no large towns.

There is a natural route from the West Coast to Dingwall via Glen Carron and Strath Bran. This also carried a drove road, with a crossing to Skye from Kyle to Kyleakin. There were many possible routes considered for a Skye railway, but when the Skye railway came it followed this route. The Dingwall & Skye Railway was opened in 1870 from Dingwall to the ferry crossing at Stromeferry. A branch was built from this line, close to Dingwall, to Strathpeffer in 1885. The route was completed by extension to Kyle of Lochalsh in 1897.

For a full introduction and discussion of the history of these lines the reader is referred to other books listed in the Further Reading section of this book.

Dingwall & Skye Railway

The driving force behind the Dingwall & Skye Railway was Sir Alexander Matheson. He and William Jardine had made their fortunes trading opium. He later became a banker and MP. Matheson owned a number of estates in the north of Scotland including Alness (Castle Ardross), Loch Duich, Loch Alsh and Attadale (ancestral home of the Matheson Clan) and relatives owned the Isle of Lewis. He was involved in railways before the Skye line, serving as chairman of the Inverness & Aberdeen Junction Railway from 1856 to 1865 and of the Highland Railway from 1865 to 1884. Matheson was to build Duncraig Castle near Plockton in the 1860s. There were other local landowners involved in the promotion of the line, including MacLeod of MacLeod of Skye.

The engineer was Joseph Mitchell, whose superbly engineered railways crossing difficult terrain already ran from Perth to Forres and from Keith to Bonar Bridge via Forres, Inverness and Invergordon – a line which was ultimately to reach Thurso and Wick.

The company secretary was Andrew Dougall, who managed the lines built by Mitchell and was the secretary of the HR from 1865 to 1896.

The Skye railway was first discussed in 1864. Over a series of meetings the Dingwall to Kyle of Lochalsh route was recommended, possible traffic discussed and the majority of the land granted in exchange for shares. Traffic from Skye, Lewis, Gairloch and Ullapool was considered likely, as was the carriage of cattle, sheep, fish, passengers and tourists. There were the usual difficulties calling on shares and placating landowners, but the Bill preparation went ahead. Despite the Act for the 63-mile line being passed on 5 July 1865 no work began, due largely to lack of finance and a difficult landowner, Sir William McKenzie of Coul House. He required various accommodations at Strathpeffer, such as the line being in a tunnel through his land. A revised Act of 1868 reduced the cost of building the line and placated the difficult landowners. In the west the line was cut back to Attadale, thus avoiding building the line along the sheer shore of Loch Carron. There was a deviation at Achnashellach and a major alteration of the route to run via Raven's Rock, which avoided Coul House but regrettably would not serve Strathpeffer and Contin.

Construction of this 53-mile route began in 1868. In 1869 the Attadale terminus was considered inappropriate and works extended to Stromeferry, requiring heavy works. This was a sensible extension as the road from the south crossed Loch Carron at this point and this would allow passengers to continue to Kyle, Plockton and points north and south by road. The road on the south bank of Loch Carron between Attadale and Stromeferry was not opened until 1970. Stromeferry was not an ideal harbour either: there are strong tides and dangerous rocks off Port Hulin and Plockton which had to be buoyed but were not at this time. In preparation for opening, the company approached the HR to operate the line (they agreed) and David Hutcheson to provide steamer links

to Portree and Stornoway (he did not, due to the length of diversion to existing steamer routes in order to reach Stromeferry, and the company had to acquire its own vessels).

As construction took place, the possibility of hauling fishing boats from the Dingwall Canal west to Kyle was explored. With this in mind, stations were built with low platforms and large gaps between loop lines and the overbridge at Garve had a larger than usual clearance. Although this did not go ahead, small craft have been carried on the line.

Official opening, with a banquet, was on 19 August 1870 and the public opening was the next day. Goods haulage had begun on the 5th. *The Illustrated London News* welcomed the opening and noted that given the outbreak of the Franco-Prussian War the line might provide an outlet for tourists who would normally travel to the continent.

On opening there were two trains per day, taking three hours each way. Stations were provided at Strathpeffer, Garve, Achanalt, Achnasheen, Strathcarron and Strome Ferry. The steamers *Oscar* and *Jura* continued to Portree and Stornoway respectively. After the wrecking of *Oscar* at Applecross, *Jura* met a Hutcheson vessel for Stornoway at Portree. *Jura* was replaced by the ageing *Carham*, ex of the North British, in 1871. Fish traffic was carried immediately, taking fish to London more quickly than previously possible. By 1872 the company had the mail contract for Portree.

Private stations were opened at Lochluichart (for Lady Ashburton; relocated further west and made public on 1 July 1871), Achnashellach (for Lord Hill / Tennant; made public 1 May 1871), Glencarron Platform (1872 for Shaw of Glencarron; public possibly 1 August 1873) and a public station opened at Attadale (in the 1870s) largely for the use of the Mathesons.

Ferret took over from *Carham*, now the spare vessel, in 1874. Both vessels and the Strome ferry were taken over by the HR in 1877. On 19 April 1880 David MacBrayne took over the steamer services. The Highland disposed of *Carham* and *Ferret* was chartered, unwittingly, to a con artist who travelled much of the world before being apprehended (see John Thomas's book, listed under Further Reading).

Initially two 2-4-0 engines (Seafield class, formerly goods) were used, one at Dingwall and the other at Strome. Due to the tight curves of the line two engines of this class were modified to become 4-4-0 bogies in 1873 and 1875. In 1882 the first locomotive specifically designed for the line, the 4-4-0 Skye Bogie, was introduced and due to its success eight more were built.

The Highland and Dingwall & Skye Railways (Amalgamation) Act of 2 August 1880 authorised the acquisition of the company by the HR. This arose because the company was struggling to pay interest on loans. In addition, the completion of the Callander & Oban Railway (C&O) to Oban meant that much of the lucrative fish traffic immediately diverted to travel south by that line. To compensate for the longer sea route to Oban the C&O offered competitive rates, a shorter rail distance, new facilities and rapid handling and dispatch of goods.

During the 1883 herring season, soldiers were required to keep the peace at Stromeferry. Local feeling was that unloading of fishing boats and the running of

trains broke the Sabbath and the pier was occupied on 1 June. The presence, and later threat of dispatch, of soldiers kept the pier open on subsequent Sundays for fish traffic. In order to regain some of the fish traffic, Loch Carron was buoyed and lighthouses built to allow shipping to operate in the dark and traffic improved in 1886.

The HR's branch to Strathpeffer opened in 1885, bringing some more traffic to the far eastern end of the line between Fodderty Junction and Dingwall.

The HR ran 'mixed trains' i.e. combined goods and passenger trains. Achnashellach station is a summit and while crew split a westbound train here in 1892 the train, with a failed brakevan, ran downhill to the east. On reaching the rising approach to Glen Carron Platform, its direction reversed. The engine crew had pursued the train and the two collided. The Board of Trade disapproved of the HR's practise of placing the passenger portion in the rear of mixed trains – thus without continuous brakes. A further incident occurred in 1897 when a coupling broke and a train, including occupied passenger carriages, ran backwards from Raven's Rock downhill through Fodderty Junction and a level crossing to not far from Dingwall station. After this, marshalling of trains was changed and the overall number of mixed trains reduced.

In 1893 signal boxes opened with Strathcarron, Achnasheen, Achanalt and Garve requiring two boxes due to the length of their loops.

The extension of the line to Kyle of Lochalsh opened on 2 November 1897. This took the line to the originally intended terminus. Steamer services transferred to Kyle (the pier at Stromeferry survived until 1937).

During the First World War the line was taken over by the Admiralty, with only one HR train allowed per day. London & North Western Railway 4-4-2Ts were drafted in to operate the line. The 1914 Luib Siding, at the west end of Loch Sgamhain, was re-laid as a loop and siding in 1918. There was a considerable quantity of traffic from Kyle to Invergordon in 1918 due to the laying of the Northern Barrage minefield. After 1919 the loop survived as a refuge siding. During both wars much tree felling took place along the line, with temporary sidings laid to assist with this traffic. In the Second World War further minefield and other naval traffic would use the line again as the west coast lochs became busy with wartime traffic which could not use east coast ports.

On 1 May 1954 Lochluichart station and 2 miles of track closed. The Conon Valley Hydro Scheme was to raise the level of Loch Luichart and a deviation of the line was needed. The deviation opened two days later and this increased the length of the Kyle line by 40 yards.

With Kyle being so far from sources of coal, there was much expense in hauling coal to the locomotive shed, making this an obvious line to convert to diesel as soon as possible. The shed at Kyle closed on 18 June 1962 and that at Dingwall followed on 31 December.

In 1963 Dr Beeching's *The Reshaping of British Railways* recommended complete closure of the Kyle line. However, it is notable that the report showed bus transport was not available for the route. At this time the Stromeferry to Strathcarron road did not exist, the ferry journey at Stromeferry still being an inconvenient necessity. The line was to survive, for now.

1964 saw the closure of many goods yards (Lochluichart, Achnashellach, Achterneed, Stromeferry, Plockton and Achanalt). Passenger services were withdrawn from Achterneed, Glencarron and Duncraig. Even more dangerous to the future of the line was a period from 1969 to 1970 when the line was closed by a rockfall caused by blasting at Attadale for a new road. With the closure of much of the C&O still fresh in mind, this was a worrying time for the line (see the *Callander & Oban Railway Through Time*, also by Amberley). This section of line was always at risk of rockfalls and the opening of a rockfall shelter at Attadale, covering both road and railway, showed some faith in the line's future. However, on 21 December 1971 it was announced that the line was to close on 1 January 1974. Further, on 24 March 1973 the Kyle to Stornoway steamer was withdrawn and two days later it re-started from Ullapool.

Closure of the smaller stations had raised awareness that the line could close entirely. Organised opposition was led by Torquil Nicolson, leader of the 'Save the Kyle Railway Line Campaign' and chairman of Cromarty County Council Planning and Development Committee, whose campaign was ultimately successful and on 31 July 1974 the line was saved. This was partly due to the development of an oil rig construction site at Loch Kishorn, to the north of Loch Carron, which would be treated as if offshore and supplied largely via a new railhead at Stromeferry built on the site of the former pier. The Ninian Central Platform was built here.

A key behind-the-scenes player in the 1964 and 1974 reprieves of the Kyle line was the late Frank Spaven. His son David writes:

> Until his 1966 move to the newly established Highlands & Islands Development Board (HIDB), Frank was one of the key Government regional planning specialists advising the Scottish Office on the economic implications of the Beeching closure proposals. In his obituary in the *Scotsman* in 2003, he was credited with being 'instrumental in saving the bulk of the Highland rail network'. Subsequently, with the HIDB, he argued strongly (and successfully) for the second reprieve of the Kyle line, which at that time was of course still a multi-purpose railway, carrying mail, parcels, sundries and freight as well as passengers.

This reprieve was not the end of troubles for Kyle. On 17 March 1975 the Kyle to Portree ferry was withdrawn, leaving only the Kyleakin ferry. Stromeferry depot closed in 1982 and road transport was used for the Loch Kishorn yard until closure in 1987. The site has seen further use; the caissons for the Skye Bridge were built here in 1992 and it is now re-opening as a renewables base.

In 1980 Michael Palin was to travel to Kyle as one of the *Great Railway Journeys of the World* (BBC Television). This journey stood out as being the only British journey in the first series – testimony to the tourist potential of the line. On 10 July 1983 Sunday services began on the Kyle line and in August the line effectively closed to goods. The quayside Kyle station sidings were reduced not long afterwards, although a loop by platform 1 (for locomotive hauled trains), a siding by the platform 2 line (for excursion

stock not in use) and a short siding by the former cattle dock were retained. However, freight has run occasionally since then, notably timber in 1987 (by mixed train) and flagstones for Kyle's seafront redevelopment in 1997.

Radio Electric Token Block signalling was introduced in 1984 and the remaining seven boxes west of Dingwall Crossing closed. Class 37 hauled trains changed to Class 156 Sprinters in 1989. On the night of 7/8 February 1989 the Ness Viaduct in Inverness collapsed, severing the Far North and Kyle lines from the rest of the railway network. Dingwall became the southern terminus of the disconnected lines, with buses running through to Inverness. Muir of Ord became a maintenance depot, with a shed brought from Barassie. Ramps were set up at Inverness and Invergordon to allow rolling stock exchange by road. The bridge was replaced and re-opened on 9 May 1990.

The Skye Bridge was opened on 16 October 1995 and the last regular ferry service from Kyle, that to Kyleakin, ceased.

Class 158s were 'cascaded' onto the Far North and Kyle lines from 1999 after Class 170s were introduced on express services in central Scotland. Beauly and Conon stations, both between Dingwall and Inverness and serviced by Kyle trains, re-opened on 15 April 2002 and 8 February 2013 respectively, but no stations on the Kyle line itself have re-opened.

Rockfalls and landslides have long been a feature of the portion of the Kyle line by the sea. A rockfall onto the A890 blocked the road but a novel use of 'holdfast units' – matting laid on the track which cars can drive along – allowed vehicles to use the neighbouring railway trackbed when trains were not running during daylight hours between March and April of 2012.

Although always a popular excursion destination for rail-tours, in recent years the 'Great Britain' steam specials have become an annual event with large numbers travelling to the area to enjoy the spectacle. 'The Royal Scotsman' continues to call in summer months, bringing some glamour to the line. There is a museum in the station at Kyle with details of the line, Highland life and the impact of the railway on the area. The signal box at Kyle has been renovated and now provides holiday accommodation.

Finally, it is worth mentioning that for an east to west journey many of the finest views – of the Beauly Firth and of Loch Carron – can be had on the right hand side of the train. But both sides enjoy views of mountains and lochs.

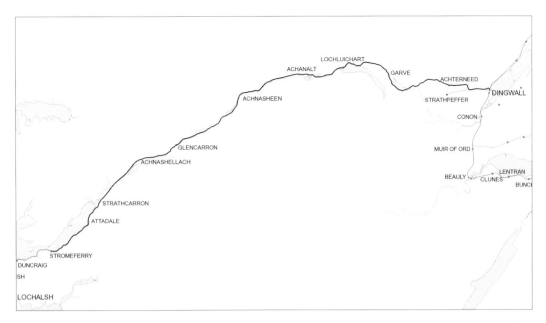

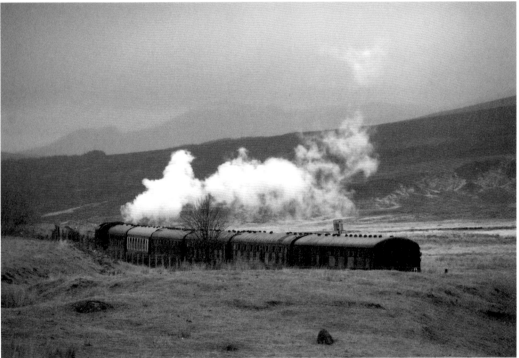

The 'Great Britain' at Achnasheen reverses to take water. (*Ewan Crawford, 26 April 2013*)

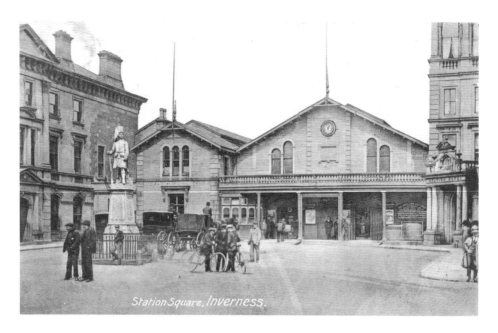

Inverness

Today trains for the Kyle line start from Inverness. This postcard view shows the station frontage with the entrance of the HR's Station Hotel, now the Royal Highland Hotel, to the right and the memorial to Cameron Highlanders lost in campaigns in Egypt and Sudan. The entrance has since been modernised, re-built in brick. (*Philco Series postcard*)

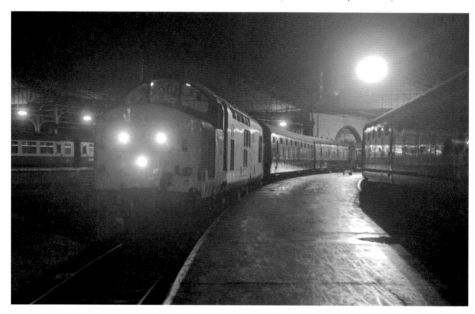

37416 starts up at platform 5, ready to leave with the 0655 to Kyle. This train was unusually busy as 37s were soon to be withdrawn from the Far North and Kyle lines. The platforms were rather low at this time, being raised when the Class 156 Sprinters were introduced. To the left of the locomotive are the platforms for the south and to the right is the 0635 to Wick and Thurso at platform 6. (*Ewan Crawford, 03/01/1989*)

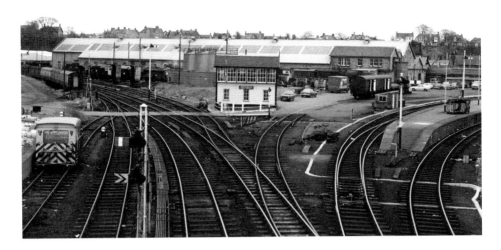

Rose Street Junction

The triangular layout at Inverness station can be seen from this view of Rose Street Junction. To the left the line runs to Welsh's Bridge Junction, where today the lines to Perth and Aberdeen part company. To the right lines run into platforms 5–7, which serve the Kyle and Far North lines; the first of these platforms opened with the Inverness & Ross-shire Railway. Running from left to right behind the former Lochgorm Works, now Inverness TMD, are the lines of platforms 1–4 which serve the Perth and Aberdeen lines. Rose Street cabin was closed and track rationalised in March 1987 when Inverness Signalling Centre took over. (*Ewan Crawford Collection*)

Looking west from the overbridge at Rose Street Junction, a 26 heads towards the Ness Viaduct, which opened with the Inverness & Ross-shire Railway of 1862. To the right is the remains of the Inverness Harbour branch, which opened with the Inverness & Nairn Railway in 1855 and closed to passengers in 1867. For the first 19 miles Kyle trains use the Inverness & Ross-shire Railway to Dingwall Junction, sharing the track with trains for Thurso and Wick. (*Ewan Crawford Collection*)

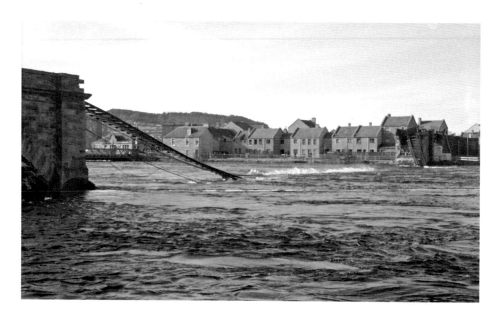

Ness Viaduct

The five-arch Ness Viaduct collapsed after heavy rainfall in the Highlands in February 1989. This was the scene at lunchtime on the 8th. The destination board in Inverness station read: 'Due to the recent flood damage, a special bus service will operate between Inverness, Muir of Ord and Dingwall connecting with all services to and from Kyle of Lochalsh, Wick and Thurso.' Six Class 37/4s and four sets of coaches were north of Inverness and these were used to continue the services. Class 156 Sprinters were moved by road from Inverness to Invergordon. On the day of the collapse, it was announced that the bridge would be re-built and a ScotRail advert of the time read: 'Are the North Highland lines all washed up? No chance.' (*Ewan Crawford, 08/02/1989*)

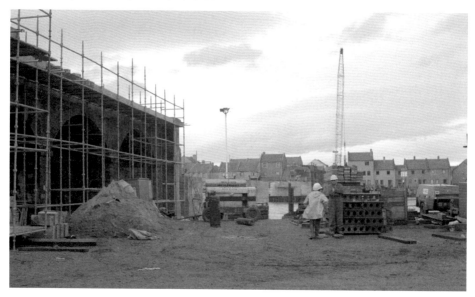

Piers for the new Ness Viaduct were taking shape in early 1990 and the remaining portion of the bridge stabilised. The new girder bridge re-opened on 9 May 1990. (*Ewan Crawford, 1990*)

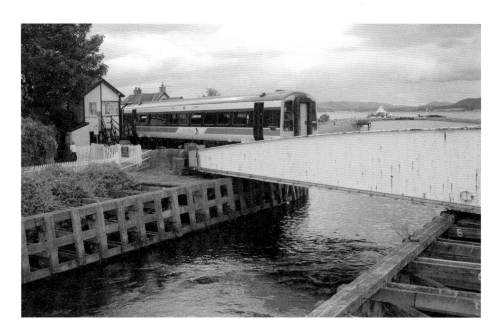

Clachnaharry

Westbound 158735 slowly crosses the swing bridge over the Caledonian Canal at Clachnaharry. The signal box was reduced to a bridge cabin in 1988 on introduction of RETB. The Beauly Firth is in the background. (*Ewan Crawford, 19/07/2004*)

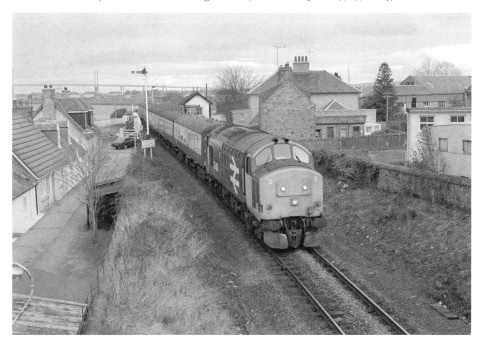

37418 passes Clachnaharry with the 1735 Inverness to Wick. The station here opened in 1869, a few years after the line, and closed in 1913, around the same time that the line from here to Clunes was doubled to cater for increasing traffic. The Kessock Viaduct can be seen in the distance. (*Graham Roose, 30/04/1986*)

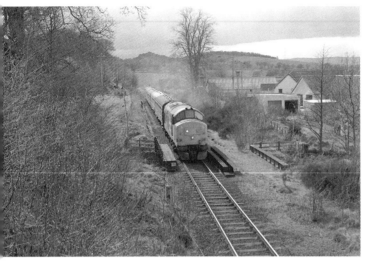

Bunchrew

37420 at Bunchrew with the 1205 Wick to Inverness. The station opened with the line and closed in 1960. The bridge seen here betrays that the line was doubled but reduced to single track in 1966. (*Graham Roose, 30/04/1986*)

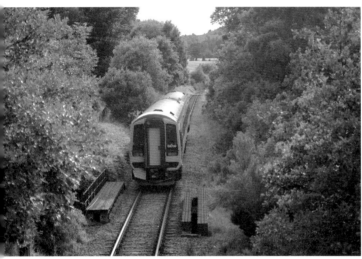

158738 passes Bunchrew heading north for Wick over the same bridge 18 years later. (*Ewan Crawford, 18/07/2004*)

Lentran

Lentran opened with the railway in 1862 and closed in 1960. It was to open again for three days in March 1982. This view shows the remaining platform from the level crossing. The timber building can just be seen to the right of the bridge parapet. A loop and siding remained here until 1988. (*Ewan Crawford, 21/07/2004*)

Little remains of the station at Clunes (opened 1864, closed 1960) and there are more scenic locations nearby! This view is of the Beauly Firth and the Safeway train, from Georgemas Junction, seen approaching Lentran from Clunes. (*Ewan Crawford, 21/07/2004*)

Beauly

Small Ben Class 4-4-0 14415 *Ben Bhach Ard* (ten miles west of Beauly) pauses at the south end of Beauly station with an Inverness-bound goods train. These locomotives were used extensively on the Kyle line to haul mines to Admiralty yards at Invergordon in 1918 and thereafter in the 1920s and for summer traffic until 1938, with some used on the Strathpeffer branch. This particular locomotive was built in 1906 and withdrawn in 1948. (*Ewan Crawford Collection, 08/1938*)

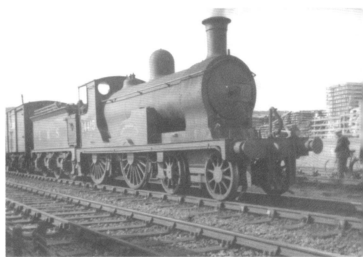

Beauly station opened with the line but closed in 1960. It was to reopen in 2002 but with a very short platform. As a result, passengers must detrain from a particular pair of carriages. The building to the left was the main station building on the Inverness-bound platform and is now a house. A similar station reopened at Conon on 8 February 2013, the original having opened with the line and closed in 1960. (*John Furnevel, 23/11/2003*)

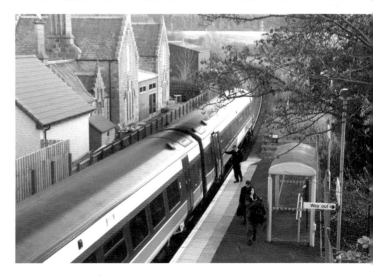

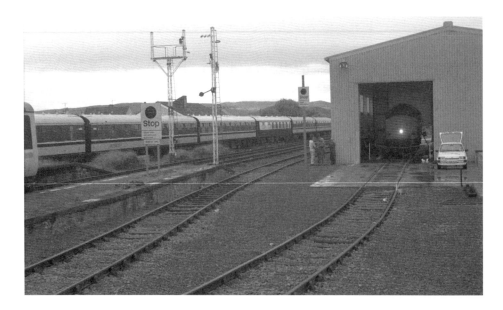

Muir of Ord

Muir of Ord opened with the line and closed in 1960. It reopened in 1976. After the collapse of the Ness Viaduct, the station's goods yard was converted into a maintenance depot in March 1989. The grain silo sidings to the far left were used to hold unused carriages and Sprinters (one is seen extreme left in the station) and 37s fuelled at the south end of the station. A shed brought from Barassie was re-erected on the site of the goods shed, which was demolished, to be a running shed. Passenger trains did not serve the station and a minibus operated until re-opening in 1990. The signalposts were made redundant in 1988 when RETB was introduced. (*Ewan Crawford, Summer 1989*)

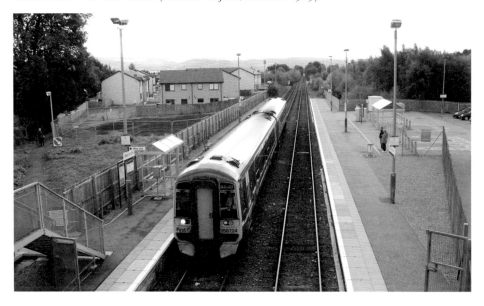

The grain silos, sidings, shed and station building are all swept away now but the station remains open for Kyle and Far North trains. The train seen here is northbound, the direction of the loop having been reversed. (*Ewan Crawford, 30/09/2009*)

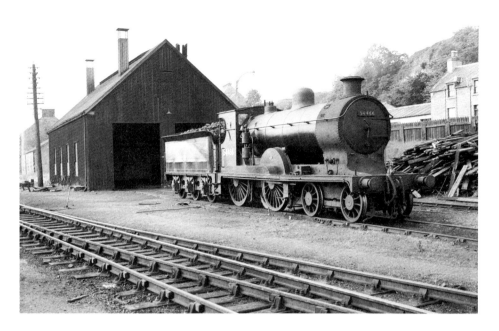

Dingwall

From the opening of the Dingwall & Skye Railway in 1870 a locomotive shed existed at the south end of Dingwall station, on the west side of the line. The locomotive is 54466, a Caledonian Railway Pickersgill Class 113 3P 4-4-0 of 1916, withdrawn in 1962 from Aviemore shed. (*Ewan Crawford Collection, 1950s*)

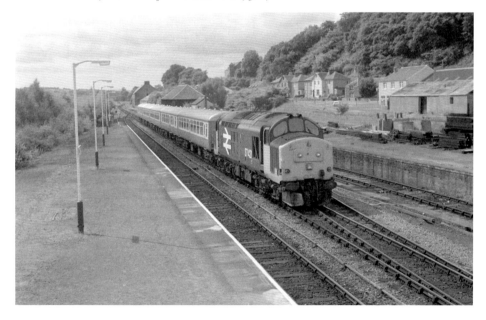

37421 enters Dingwall from the south with empty stock for the Dingwall to Kyle service in the summer of 1989 while the Ness Viaduct was down. Although two Sprinters had been brought to Invergordon to operate the Far North line the Kyle line was still in the hands of 37s. The shed was located beyond the goods shed seen above the carriages. (*Ewan Crawford, Summer 1989*)

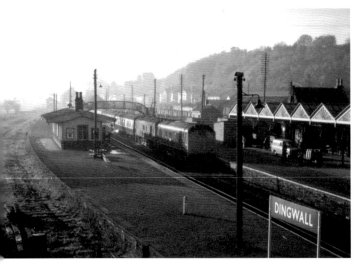

A train for the far north rolls into Dingwall station on a bright but hazy November morning behind a pair of Inverness-based Type 2 locomotives. Note the trolleyload of milk churns standing on the platform. The yard to the left was lifted in the late 1960s and was reverting to nature. (*Colin Miller, 1970*)

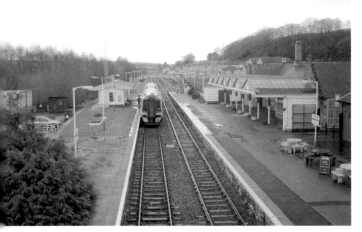

A very early southbound service at Dingwall. The passenger station hasn't altered much since 1970. The yard to the left has become a car park. Flats had been built on the site of the former goods yard and locomotive shed and are in the distant right. (*Ewan Crawford, 13/02/2002*)

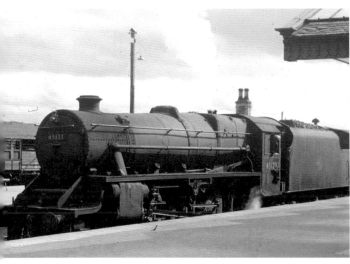

Black 5 No. 45123 stands at the head of a train at the north end of Dingwall station. This was the last full year for this locomotive. Black 5s followed HR Clan Goods onto the Kyle line. The Clan Goods had required enlargement of the Kyle turntable on introduction. (*Colin Miller, 1962*)

An extremely busy train for Kyle loads at Dingwall, not only with passengers but also parcels. The train was to be hauled by 37415 and the rear was brought up by an observation car, actually a converted DMU. (*Ewan Crawford, Summer 1989*)

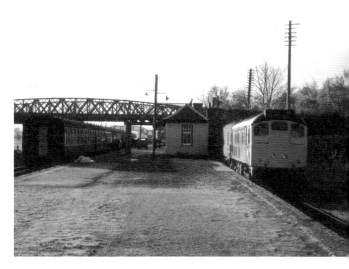

The locomotive of an early morning train for Kyle of Lochalsh collects a van from the bay at the north end of Dingwall. This bay opened with the Dingwall & Skye Railway. The Skye line ran parallel from the junction to this bay but with a connection to allow trains to run to Inverness. The layout was modified several times and yards were to develop on either side of the mainline and bay. The bay was also used by the Strathpeffer trains although when quiet these used the main northbound platform. The bridge seen here has been replaced. (*Colin Miller, 11/1970*)

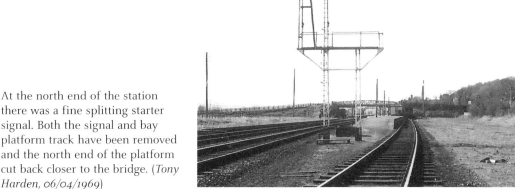

At the north end of the station there was a fine splitting starter signal. Both the signal and bay platform track have been removed and the north end of the platform cut back closer to the bridge. (*Tony Harden, 06/04/1969*)

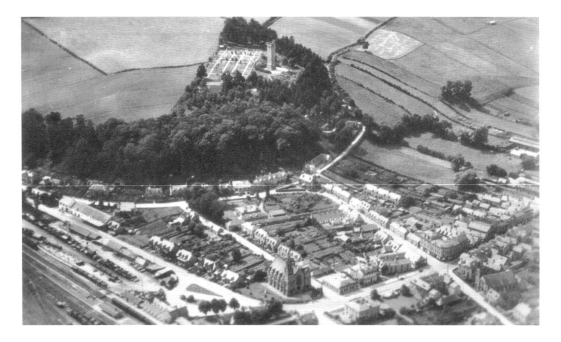

Dingwall station and goods yard appear in the bottom left of this aerial photograph of Dingwall. The monument top centre is the MacDonald memorial. A temporary inclined railway was laid to deliver stone to the site during construction. (*Aerofilms postcard, 1930*)

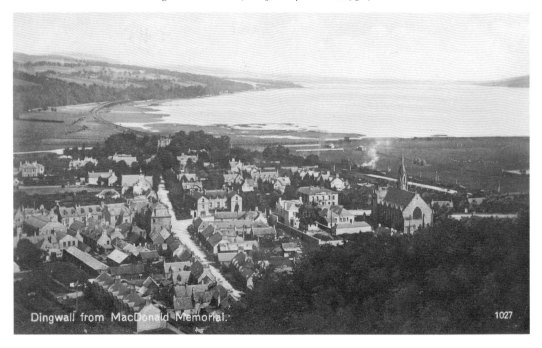

Dingwall from MacDonald Memorial. 1027

This photograph was taken from the Sir Hector MacDonald Memorial. The station can be seen on the right and the Far North line can be seen following the coastline into the top middle distance. The Kyle line curves off to the left. There's a locomotive at the north end of the station and the former North Signalbox can just be made out. (*Philco postcard*)

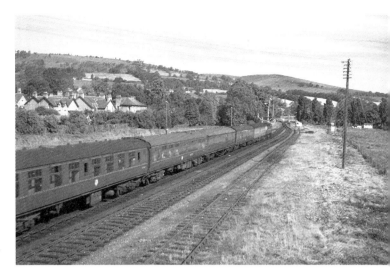

The morning train for the Far North leaves Dingwall behind a Type 2. The remains of the yards to either side of the line are becoming overgrown and the line on the right has become a siding approached from the south. (*Colin Miller, August, 1966*)

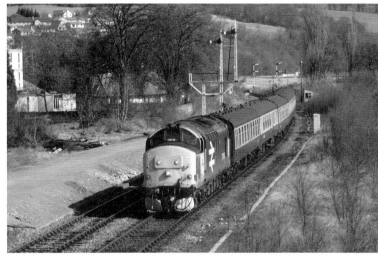

37417 enters Dingwall from the north with a train from Wick. Semaphore signals were only to survive here for two more years when the Far North lines were converted to RETB. The Kyle line was converted two years previously. (*Graham Roose, 02/05/1986*)

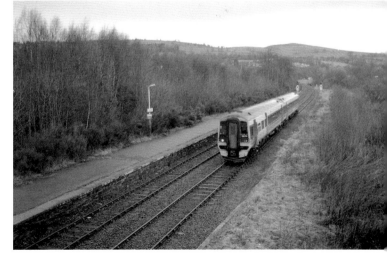

The north bay platform has reverted to nature and the semaphore signal is long gone. A 158 enters from the north with a train from Wick. (*Ewan Crawford, 13/02/2002*)

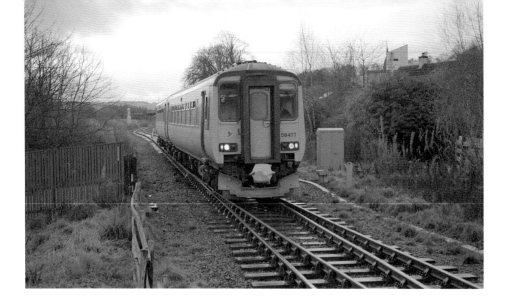

Dingwall Junction

156477 approaches Dingwall Junction from the south with a train for Kyle. The couplings at both ends were covered by a protective bag. When the Dingwall & Skye Railway originally opened, the line was double track here. The track to the left was the Far North line and to the right was the Skye line, which ran into the north bay of the station. A connection, north of the loop through the station, allowed through running to Inverness. The old Dingwall Canal passes under the line here. There was an unfullfilled plan to install cranes and lines at the Dingwall Basin and haul boats along the line. However, the passing loops were laid out with greater space between the tracks than usual and the road overbridge at Garve was bigger than usual. (*Ewan Crawford, 29/12/1994*)

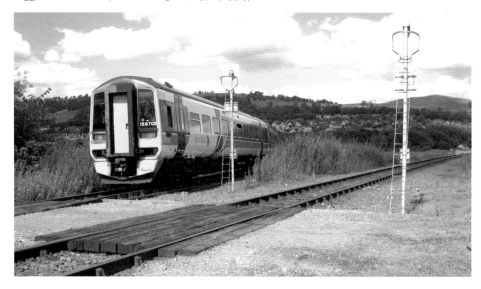

158703 comes off the Kyle line at Dingwall Junction. The line to the right is the Far North line to Thurso and Wick. The viewpoint for this, and the previous photograph, is one of the many level crossings in Dingwall. Indeed, Dingwall Crossing box was opened from 1979 to 1988 to assist with those on the Kyle line. A breakaway train, with passengers, from Raven's Rock nearly reached this junction in 1897. (*Ewan Crawford, 22/07/2004*)

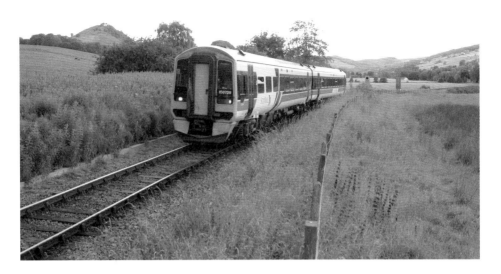

Fodderty Junction

The Strathpeffer branch opened from Fodderty Junction in 1885 and a box was provided here from 1885 to 1936 which re-opened for wartime traffic from 1940 to 1944. The branch was lifted in 1951. 158728 is seen descending from Raven's Rock with the trackbed of the former branch to the left. The distinctive hill on the left is Knockfarrel, which features in many Victorian postcards. (*Ewan Crawford, 19/07/2004*)

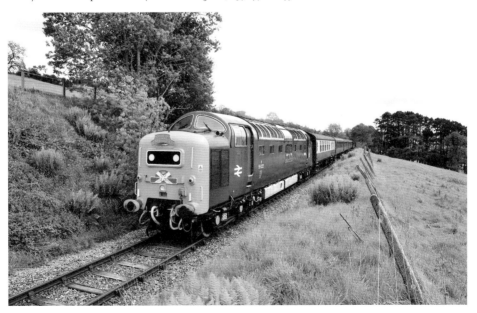

From Fodderty Junction there is a continuous 1 in 50 climb, with a brief respite at Achterneed, all the way to Raven's Rock Summit. Sparkling Deltic No. 55 022 *Royal Scots Grey* climbs the gradient with the SRPS 'Kyle Crusader' rail tour to Kyle of Lochalsh. (*John Gray, 28/05/2011*)

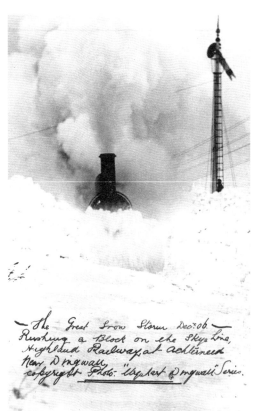

Strathpeffer/Achterneed

There was a notably harsh winter with heavy snowfall in December of 1906 and a locomotive is seen impressively 'rushing a block' near Achterneed in this postcard view. Snow was even to close the Strathpeffer branch. (*Leftwich & Co. Ltd postcard*)

Strathpeffer station opened with the line. It was not conveniently located for the town and passengers preferred to catch the coach along the road from Strathpeffer to Dingwall. A loop opened in 1871 and on the opening of the Strathpeffer branch in 1885, it was renamed Achterneed. It did provide a short break on the climb from Fodderty Junction to Raven's Rock, the line being level here. It closed in 1964 and then reopened in 1965 but closed again in 1968 with track re-alignment. The station had a large timber building on the westbound platform and low platforms which were spaced well apart. This is the view from the 10.40 Inverness to Kyle train. (*The late Frank Spaven, courtesy of David Spaven, 13/04/1968*)

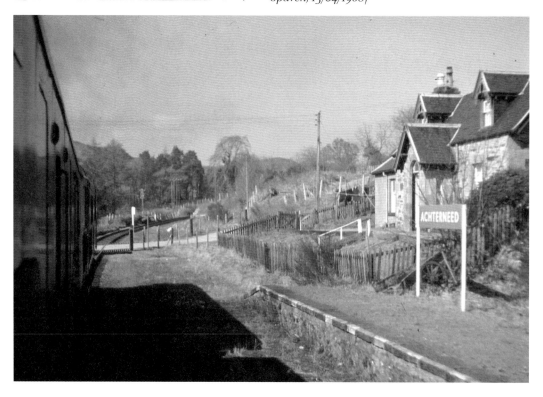

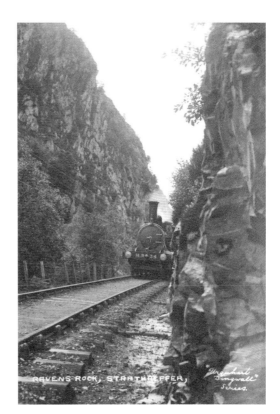

Raven's Rock
HR Skye Bogie No. 34 climbs to Raven's Rock Summit. The photographer was clearly a brave type! (*Ewan Crawford Collection*)

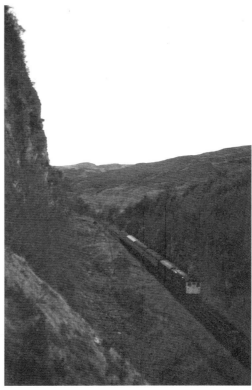

A Kyle of Lochalsh–Inverness train passes over Raven's Rock Summit in the 1970s. Quarry sidings existed here from 1923 to 1952. (*The late Frank Spaven, courtesy of David Spaven*)

Garve
At Tarvie, by the east end of Loch Garve, the line crosses this viaduct. During the First World War a siding was laid in here. (*J. B. White Ltd postcard*)

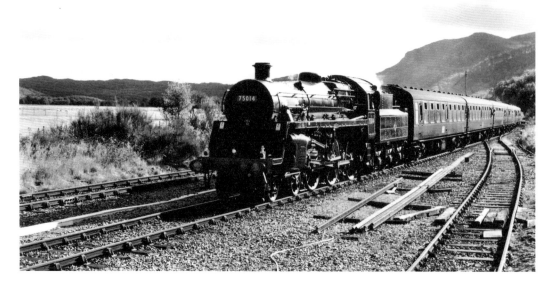

BR Standard Class 4 No. 75014 is seen approaching Garve with a special excursion from Inverness to Kyle of Lochalsh. This locomotive is now named *Braveheart*. (*John Gray, 05/10/1997*)

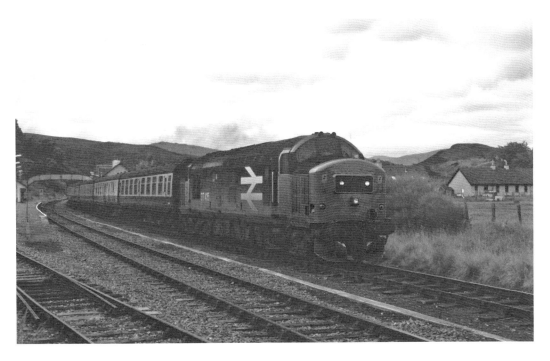

37415 leaves Garve with the 15.05 ex Kyle to Inverness. The station is the first still intact on the route with a passing loop and the 10-foot gap between lines. The goods yard was looped from the line, the approach to which is on the left. This is now a siding only. (*Ian Whitmarsh, 1988*)

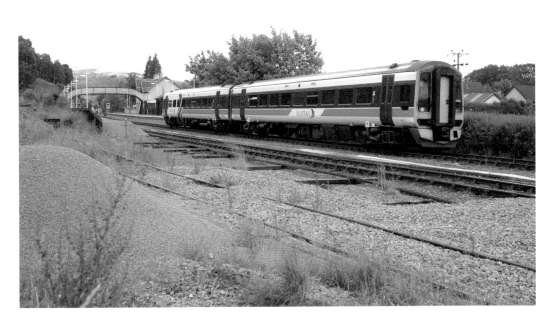

Some years later, 158720 also leaves Garve for Inverness. The shortness of the siding can be seen, it being generally only used for railway maintenance. (*Ewan Crawford, 22/07/2004*)

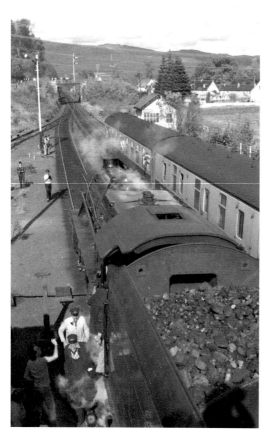

5025 took the first steam-hauled train for 20 years onto the Kyle line in 1982. This view is towards Kyle and the signalling, siding, roadbridge and signal box are all gone. After removal of the water tank, out of shot to the left, the platform was extended a little, reducing the degree of staggered platforms here. Also off to the left was the goods shed on the looped goods line. (*John Robin, 25/09/1982*)

By contrast, it was a far more prosaic scene in 2009 as 158716 crossed the level crossing which replaced the roadbridge. (*Ewan Crawford, 29/09/2009*)

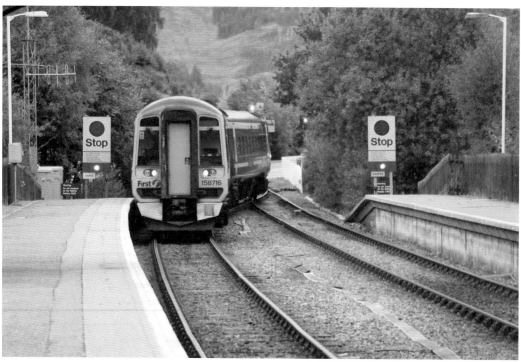

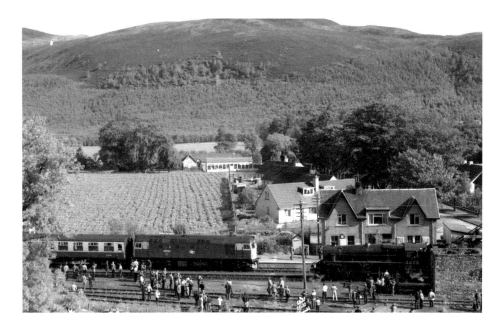

26024 draws into Garve to meet the waiting 5025 with its first public steam tour of the Kyle line. The old watertank base can be seen to the right. Garve was a sensible place for a watertank given the climbs to Raven's Rock Summit to the east and Corriemullie Summit to the west. (*John Robin, 25/09/1982*)

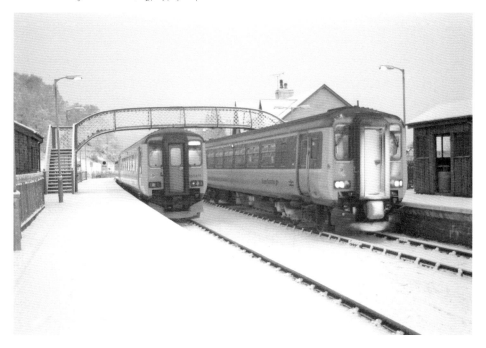

Class 156s pass with Kyle line services in the snow. Judging by the depth of the snow, I was the first person to drive west of Contin to Garve that day and I was relieved to find that the trains were running and running to time. The timber shelters were new at the time. (*Ewan Crawford, 31/12/1994*)

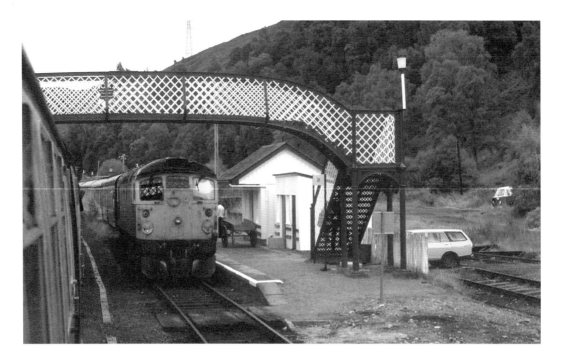

The car on the right sits where the Ullapool bus formerly connected with trains. 26s, and other Type 2s, ran on the line from 1962 until being replaced by 37s in 1983. (*Ewan Crawford Collection*)

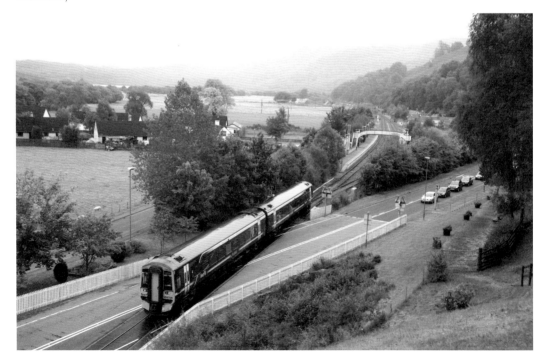

158708 is on the level crossing over the A835 and about to run into Garve station during a downpour. The train is the 1443 Kyle–Inverness. (*John Furnevel, 01/10/2009*)

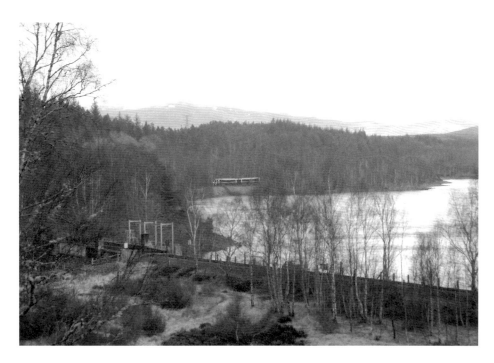

Lochluichart

The first Lochluichart station was built to serve Lady Ashburton at Lochluichart Lodge, east of the village. A 158 is seen passing close to the site of that short-lived station on the approach to Mossford Hydro Power Station. (*Ewan Crawford, 26/04/2013*)

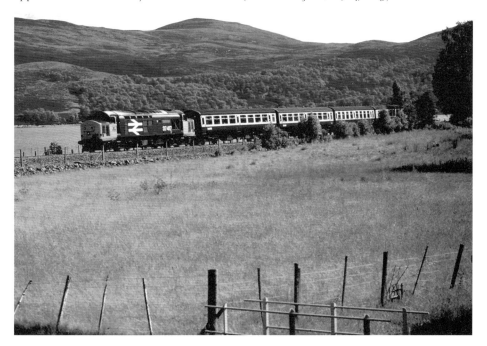

In the reverse direction, 37417 approaches beside Lochluichart with a train from Kyle. (*Martyn Hull, 17/06/1989*)

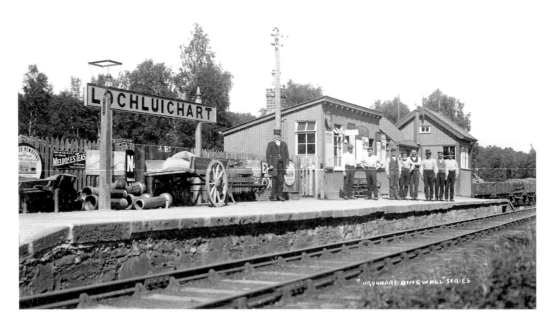

Lochluichart

The second, and public, Lochluichart station opened in 1871. It was without a loop but nonetheless had a signal box and siding by a loading bank. When the level of Lochluichart was raised, the line was diverted to a higher level course and the station replaced. The station, seen here in a view looking east, closed in May 1954. (*Tony Harden Collection*)

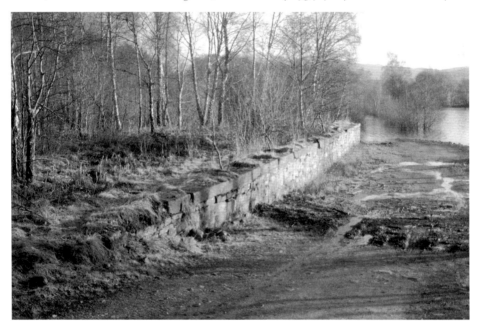

The loading bank still exists and the trackbed to the east is sometimes flooded, as in this view. The low passenger platform mound also exists but is somewhat choked with trees. (*Ewan Crawford, 02/2002*)

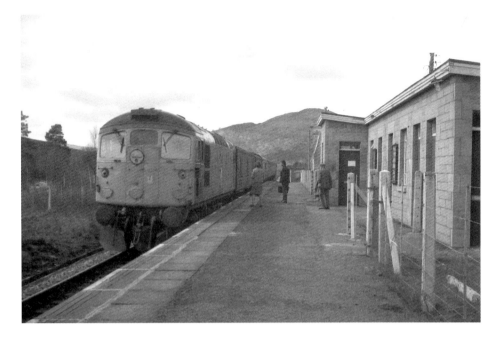

Lochluichart

A Kyle–Inverness train calls at the 1954 Lochluichart station. Whereas the original station had a siding at its east end, the new one had one at the west end but closed to goods in 1964. (*David Spaven, 1970*)

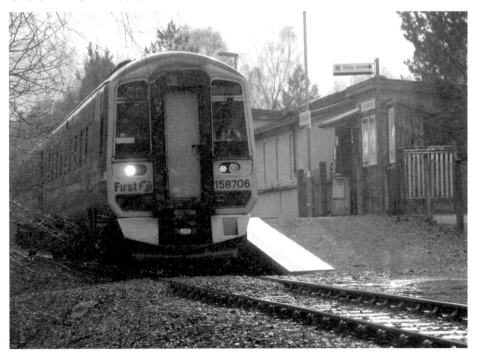

In heavy rain, 158706 breaks its eastward journey at Lochluichart. (*Ewan Crawford, 26/04/2013*)

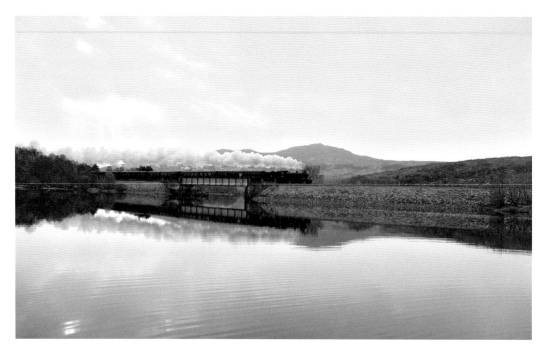

West of Lochluichart, at the end of the 1954 deviation, the railway crosses a bridge where the River Bran meets Loch Luichart. *The Great Marquess* takes the 'Great Britain IV' over the bridge on its way to Kyle of Lochalsh. (*John Gray, 19/04/2011*)

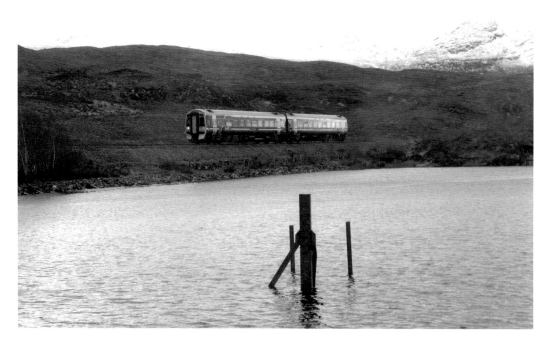

158711 heads east beside Loch a Chuilinn. The posts in the foreground are related to one of the many hydroscheme dams in the area. (*Ewan Crawford, 26/04/2013*)

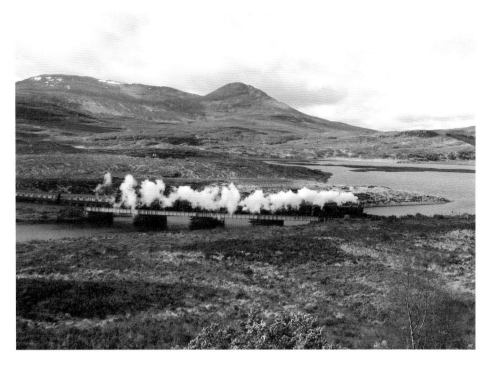

Achanalt Viaduct

K4 61994, *The Great Marquess*, pictured east of Achanalt with the 'Great Britain II' crossing the Achanalt Viaduct. Loch Achanalt is in the background, right, and Sgurr A Mhuilinn dominates the scene. (*John Gray, 11/04/2009*)

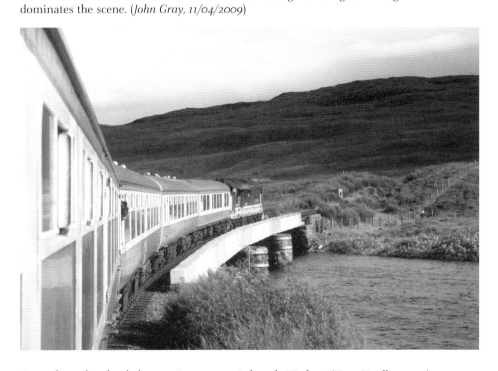

A westbound 37-hauled excursion crosses Achanalt Viaduct. (*Tony Yardley, 1994*)

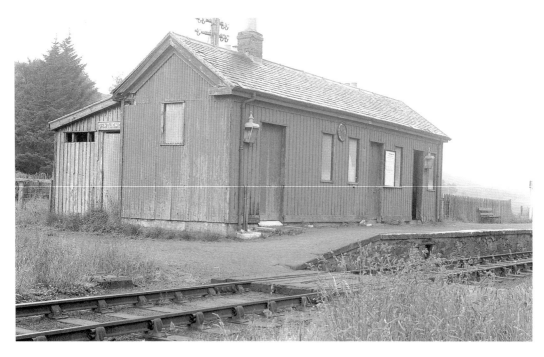

Achanalt
Achanalt had a passing loop until 1966 and a timber building, seen here in decayed condition. (*Tony Harden Collection*)

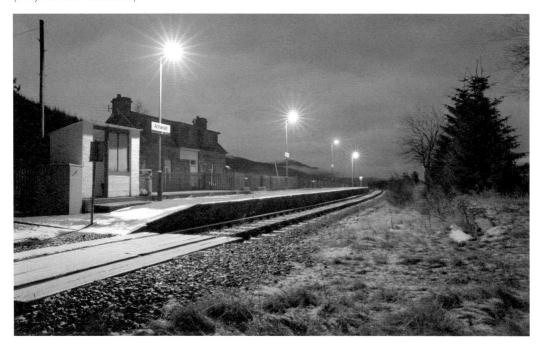

The timber building was replaced by the structure seen here and this has since been replaced with a glazed bus shelter. The remains of the westbound platform can be discerned on the right and this was one of the loops which had a 10-foot gap. (*Ewan Crawford, 28/12/1994*)

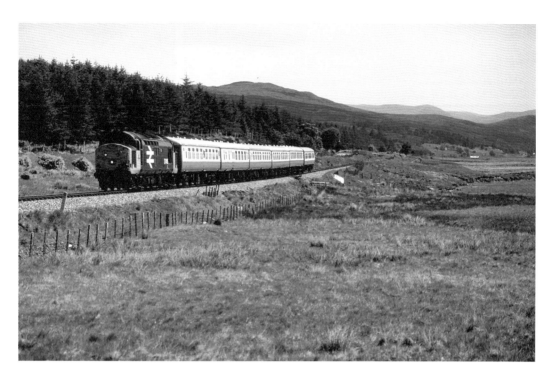

37416 heads west from Achanalt on a nearly cloudless day. (*Martyn Hull, 17/06/1989*)

A 37-hauled excursion heads towards Achanalt. One of the tight curves to be met on the Kyle line is clearly visible in this view. (*Tony Yardley, 1994*)

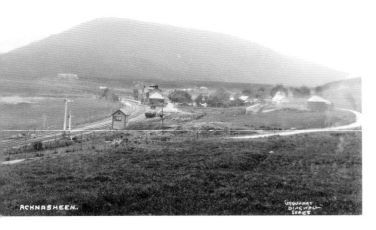

Achnasheen

Achnasheen station seen from the east, showing the two signal boxes at the east end of the station. (*Urquhart Dingwall Series postcard*)

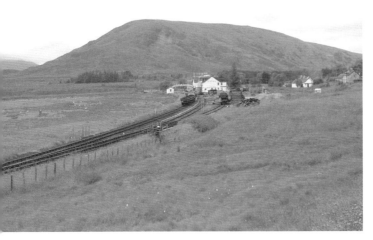

Not much seems to have changed. The signal boxes, signalling and goods shed have gone but otherwise everything looks much the same. A 37-hauled permanent way train sits in the station. (*Ewan Crawford, Summer 1989*)

The 'Great Britain VI' pauses at Achnasheen to allow Black 5 45407 to be watered and is met by a tanker at the east end of the station. An Liathanach rises above the station. (*Ewan Crawford, 26/04/2013*)

A tablet exchange takes place at Achnasheen east box. The entry to the former goods sidings is seen from a westbound train. (*John McIntyre, 04/1979*)

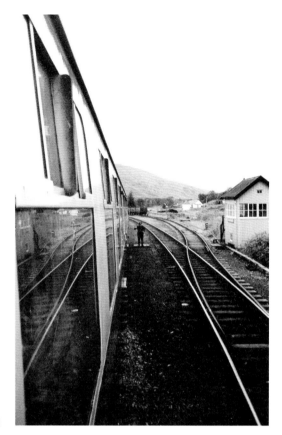

Achnasheen Station Hotel and the west box seen from a westbound train. The road to Loch Maree and Gairloch parts from the railway here and MacBrayne's buses for those destinations met the trains. (*Ewan Crawford Collection, 09/1973*)

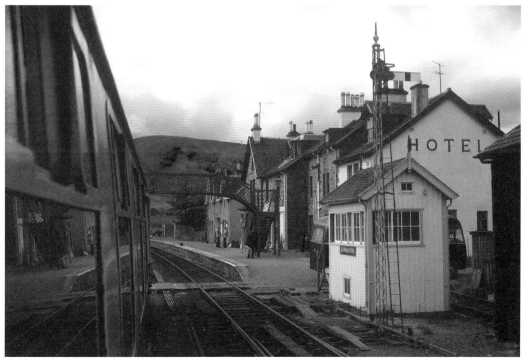

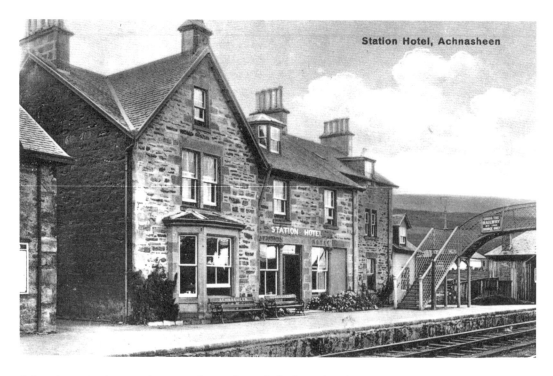

Achnasheen Station Hotel was on the eastbound platform, beside the station building. The bar of this hotel opened onto the platform, which was well known by the passengers, often leading to delayed departures. (*Ewan Crawford Collection*)

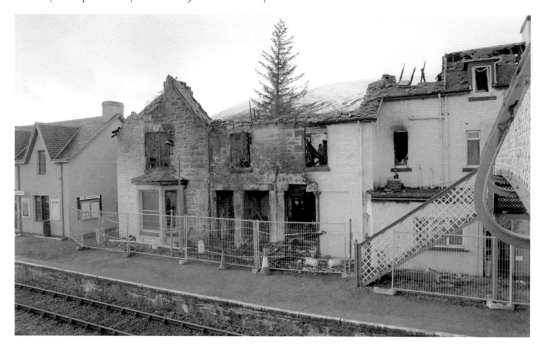

Sadly, the hotel burned down in 1995 and has been demolished. This photograph was taken not long after the fire. (*Ewan Crawford, 1995*)

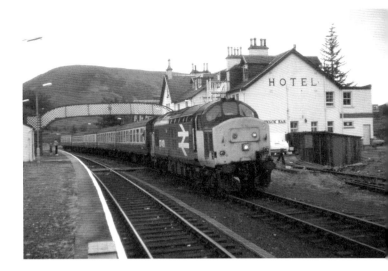

37419 at Achnasheen with an eastbound train. (*John McIntyre, 1987*)

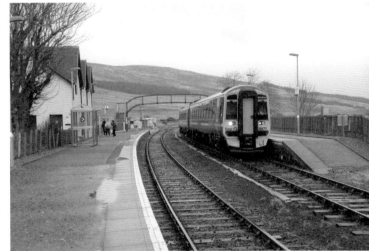

158711 leaves Achnasheen with a westbound train. The toilets in the station building, left, are noted for their cleanliness. (*Ewan Crawford, 26/04/2013*)

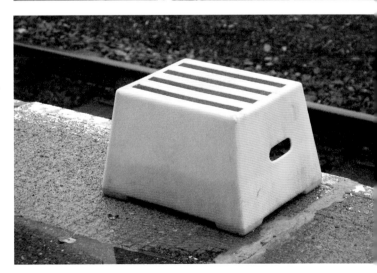

The Kyle line stations, in common with those of the HR system, had low platforms. To assist in alighting and boarding trains, wooden steps were available at the stations. This modern plastic example was found at Achnasheen in 2009. Given that all the platforms were raised when Sprinters were introduced, this came as quite a surprise to me. (*Ewan Crawford, 29/09/2009*)

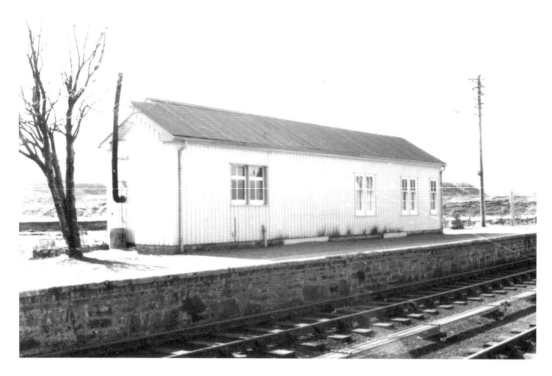

This was the station building on the westbound platform. Since being demolished, it has been replaced with several variations on a bus shelter. (*Tony Harden, 07/04/1969*)

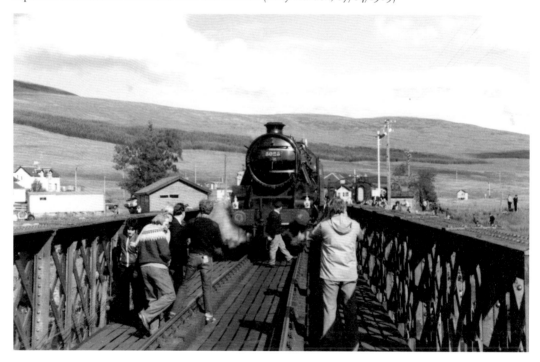

While 5025 pauses at Achnasheen, photographers detrain and really make themselves at home. The view is from the bridge immediately west of the station. (*John Robin, 25/09/1982*)

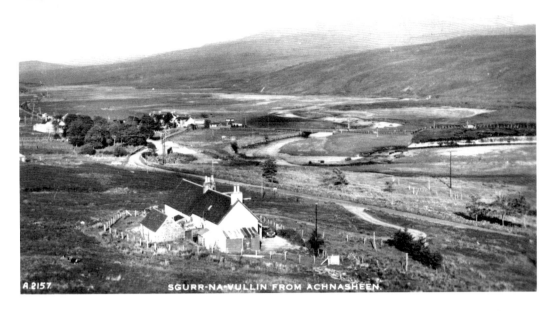

SGURR-NA-VULLIN FROM ACHNASHEEN.

A.2157

The remoteness, and some suggestion of how small a settlement Achnasheen is, can be seen in this photograph looking east towards the station. The watertank can be seen, just to the right of the station buildings. (*J. B. White Ltd postcard*)

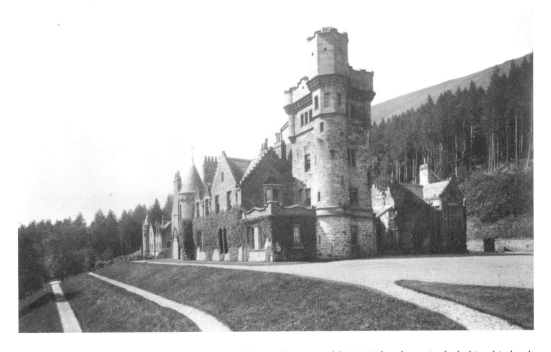

Loch Rosque Castle was a lodge owned by Arthur Bignold, MP. It has been included in this book as for the entire length of the line there were various lodges owned by major landowners and served by the railway. Many of the landowners had been contributors to the railway and, not surprisingly, asked for stations nearby. This lodge is now demolished. (*J. B. White Ltd postcard*)

Luib Summit
158727 passing east at Luib Summit, the highest point on the line at 646 feet. (*Ewan Crawford, 01/06/2002*)

A double-headed excursion heads west towards Luib Summit. (*Ewan Crawford, 01/06/2002*)

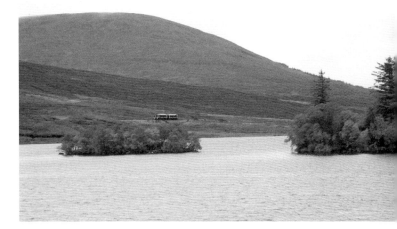

A westbound 158 approaches the site of Loan Crossing. This was at the west end of Loch Sgamhain. (*Ewan Crawford, 30/09/2009*)

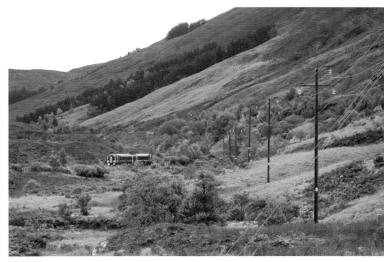

On the descent from Loan Crossing to Glencarron, a 158 heads west into Glen Carron. (*Ewan Crawford, 29/09/2009*)

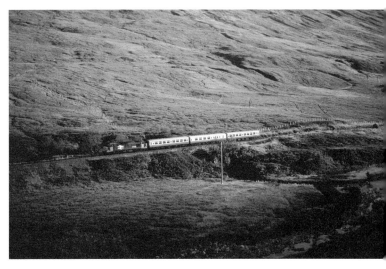

37421 heads west on the climb from Glencarron towards Achnasheen. (*Martyn Hull, 01/10/1989*)

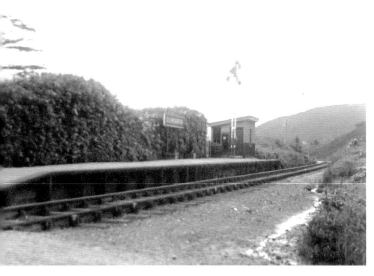

Glencarron

Glencarron opened in 1873 and closed in 1964. Until 1962 it was Glencarron Platform. This station had signals which were operated by passengers to stop the trains. (*Tony Harden Collection*)

The station is partly encroached on by rhododendrons but remains surprisingly intact. Here, it is viewed from the level crossing at the east end. (*Ewan Crawford, 25/04/2013*)

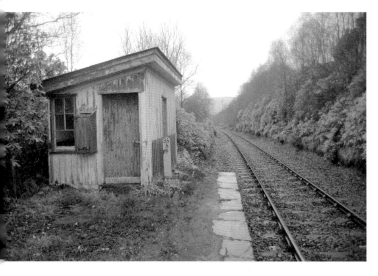

Before becoming quite so overgrown, the shelter building could be seen to be fairly intact, bar a few broken windows. (*Ewan Crawford 10/02/2002*)

Achnashellach

Achnashellach's main station building and signal box were on the westbound platform. This was not one of the original loops but it gained one before losing it in 1966. (*Tony Harden Collection*)

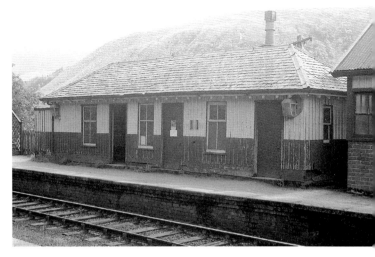

The eastbound platform still remains, although usually very overgrown. After a tidy back in 2002 it was possible to see the platform and the base of the footbridge again. (*Ewan Crawford, 02/2002*)

Happy hikers arriving at Achnashellach off the 1715 ex-Kyle of Lochalsh on 29 September 2009. (*John Furnevel, 29/09/2009*)

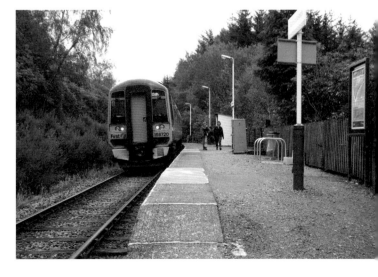

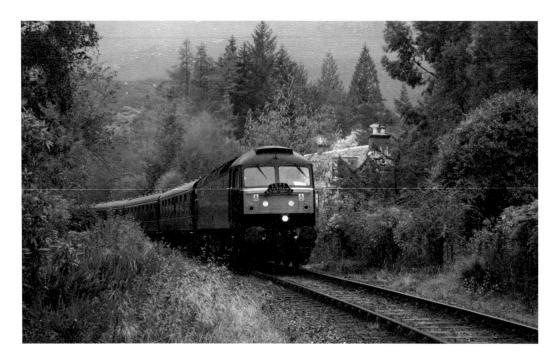

47776 approaching the platform at Achnashellach on 26 September 2009 at the head of an SRPS rail tour returning from Kyle of Lochalsh to Paisley Gilmour Street. To the right stands the former station master's house and loading bank. (*John Furnevel, 26/09/2009*)

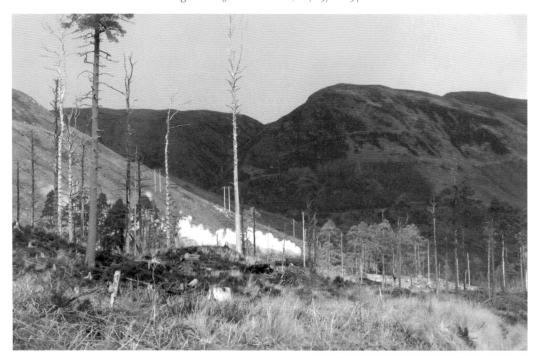

The 'Great Britain' of 2013 passes east through the Scots pines above Achnashellach Lodge. (*Michael Gibb, 26/04/2013*)

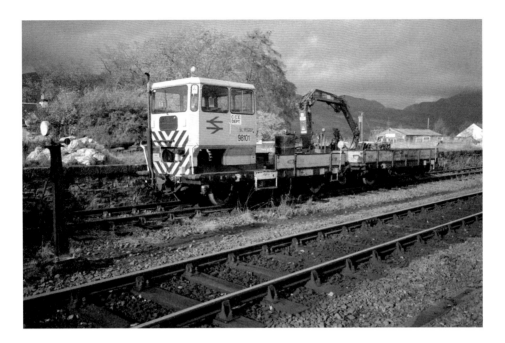

Strathcarron

A maintenance trolley sits in the siding at the east end of Stathcarron station. The goods shed once stood beyond. An old manson tablet exchanger stands to the left and the BR logo appears to be the mirror image of the usual. (*Sandy Steeperton, 22/10/1989*)

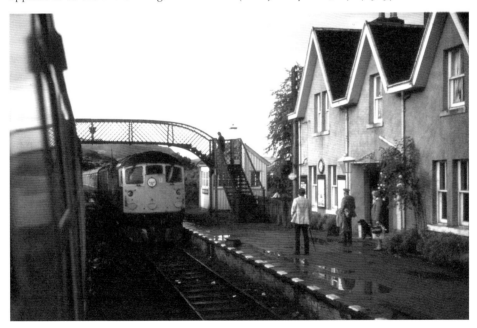

Trains crossing at Strathcarron station following a shower of rain in the summer of 1974. Approaching the camera is a Class 26-hauled service from Kyle of Lochalsh bound for Inverness. Strathcarron is the railhead for New Kelso, Lochcarron, Jeanstown and Applecross. (*David Spaven, 1974*)

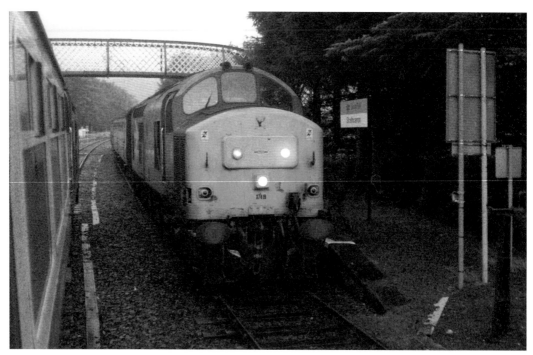

37416 meets 37419 (right) on the Inverness to Kyle run. The weather was somewhat dreich. (*Ewan Crawford, 03/01/1989*)

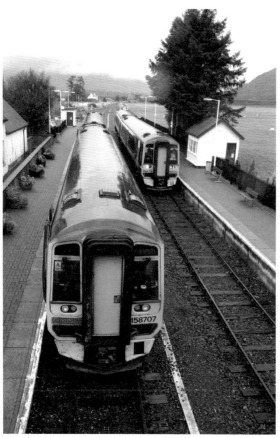

The 1203 ex-Kyle of Lochalsh meets the 1101 ex-Inverness at Strathcarron. (*John Furnevel, 28/09/2009*)

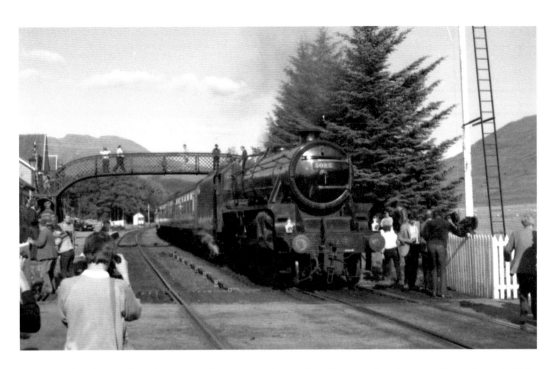

5026 arrives at Strathcarron and pauses at the station. Once again, photographers abound! (*John Robin, 25/09/1982*)

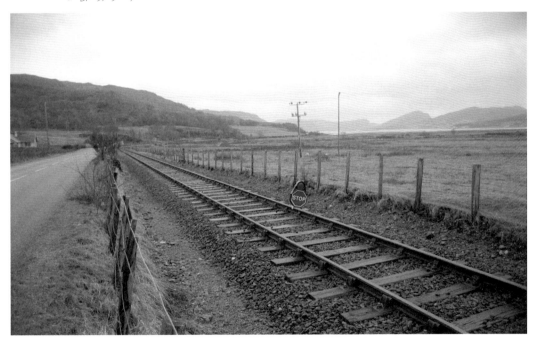

Numerous similar arrangements must have been made over the years, as the Kyle line has suffered many rockfalls. This was the stop marker in place at Strathcarron in 2001 when it became the terminus of the line, with a bus taking passengers forwards to the other stations, all except Duncraig. (*Ewan Crawford, 02/2002*)

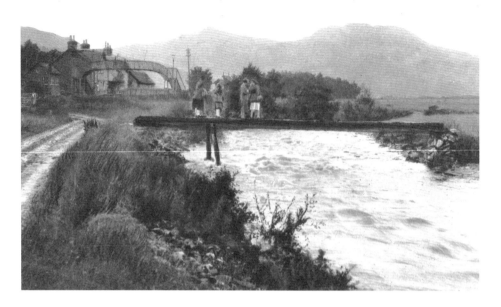

The road west from Strathcarron to Stromeferry did not exist when this photograph was taken. At the time, this dirt track would only have run as far as Attadale. (*Hugh Mackenzie, Lochcarron Emporium postcard*)

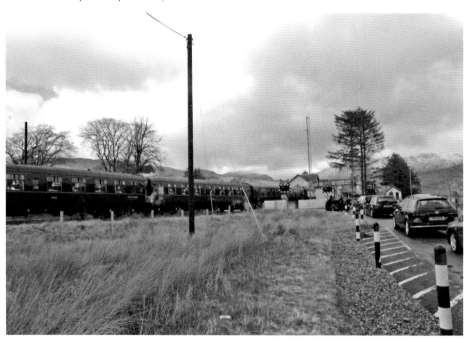

Today, the road is far busier. When the 'Great Britain' called in 2013, it was such a long train that it fouled the level crossing and caused quite a tailback of track. Then again, much of the traffic was there precisely because the 'Great Britain' was running. (*Ewan Crawford, 26/04/2013*)

Attadale

Attadale was going to be the terminus of the line when the finances required that it not run through to Kyle. This was the ancestral seat of the Mathesons and a station was here certainly by 1880. It was not formally a private station but few other passengers would use it. This photograph was taken of the shelter from a westbound train. (*Stuart Rankin, 19/06/1971*)

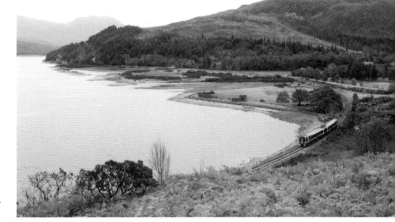

A 158 runs east beside Loch Carron near Attadale station (in the distance). (*Ewan Crawford, 01/10/2009*)

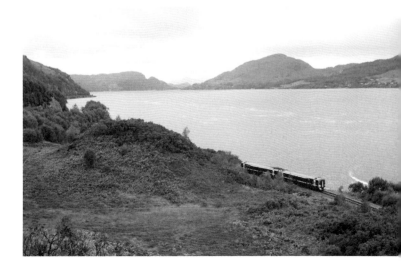

Having left the rockfall shelter, a 158 runs east beside Loch Carron towards Attadale. (*Ewan Crawford, 01/10/2009*)

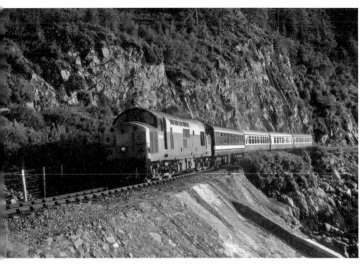

37025 approaches Attadale from the west with the 1205 ex Kyle. (*Ewan Crawford Collection, 11/09/1991*)

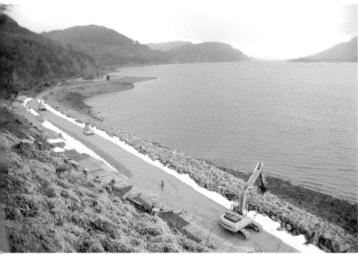

In late 2001, a rockfall and mudslide onto the Kyle line east of Stromeferry closed the railway. Unfortunately it was not at the rockfall shelter and a new alignment, moved slightly away from the mud bank, was required. While repairs took place a bus operated between Strathcarron and Kyle, calling at all stations except Duncraig. This view looks west with the new formation closer to the sea than the older route, which is covered with tarpaulins. (*Ewan Crawford, 02/2002*)

At the same location, this was the view looking east. (*Ewan Crawford, 02/2002*)

After the new trackbed was prepared, fencing was placed above the line to catch falling boulders, as seen here. (*Ewan Crawford, 07/2002*)

A 158 approaches Stromeferry from the east, running along the new alignment. (*Ewan Crawford, 25/04/2013*)

Stromeferry

The Howard Doris sidings at Stromeferry, as seen from a westbound train. A fair amount of land was reclaimed from the sea to build this depot, being considerably larger than the original Stromeferry Pier. (*John McIntyre, 04/1979*)

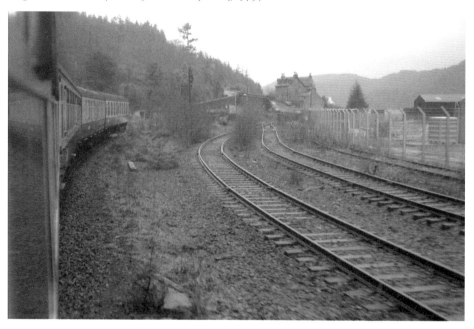

A similar view from an eastbound train shows the sidings after they had fallen out of use and were disconnected from the line. The sidings remained for a few more years in their disconnected state. (*Ewan Crawford, 03/01/1989*)

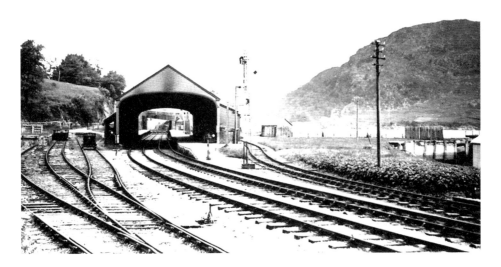

This view shows Stromeferry after the line was extended west to Kyle of Lochalsh. The overall roof seen here is not the original one (which burned down in 1891). This was located at the east end of today's station and only covered the eastbound platform; the entire westbound platform was outwith the shelter and further west. The pier to the right was served by rail originally and there was a goods shed on the approach to the pier. (*Tony Harden Collection*)

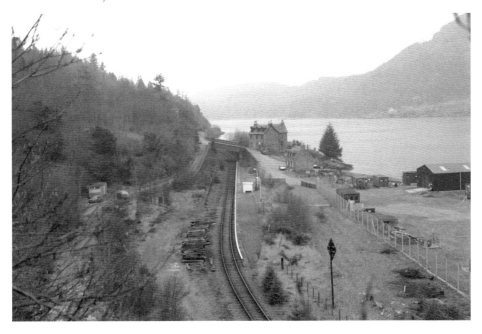

By 1991 the station was fairly desolate, having lost all sidings and most buildings. (*Ewan Crawford, 1991*)

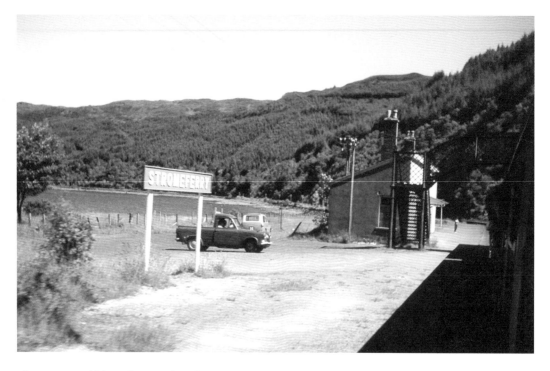

This view would have been within the overall roof of the station had it not been demolished. The view looks east. (*Stuart Rankin, 19/06/1971*)

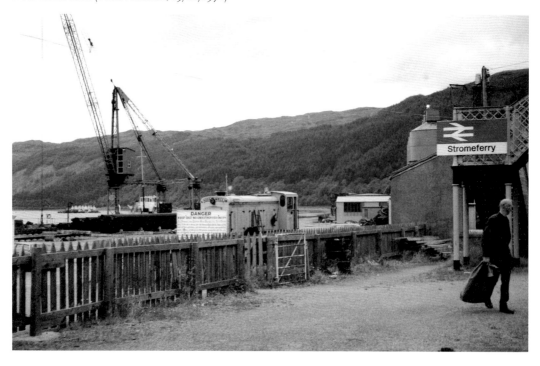

A few years later, the Howard Doris depot is established by the station and the view is slightly different. (*John McIntyre, 04/1979*)

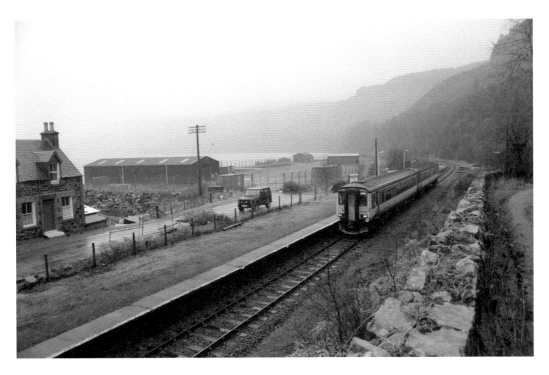

A westbound 156458 sprinter pauses at Stromeferry. (*Ewan Crawford, 28/12/1994*)

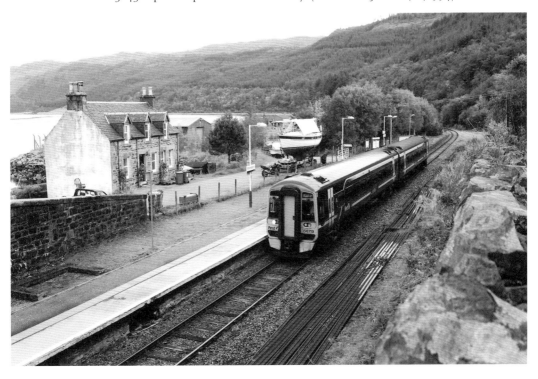

A few years later the view is similar, if slightly more verdant, and 158719 pauses while running west to Kyle. (*Ewan Crawford, 01/10/2009*)

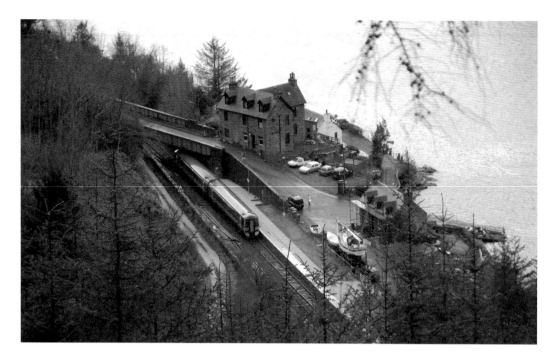

A 158 sets out west from Stromeferry. Much material had to be removed here to extend the line westwards and install this large girder bridge. (*Ewan Crawford, 26/04/2013*)

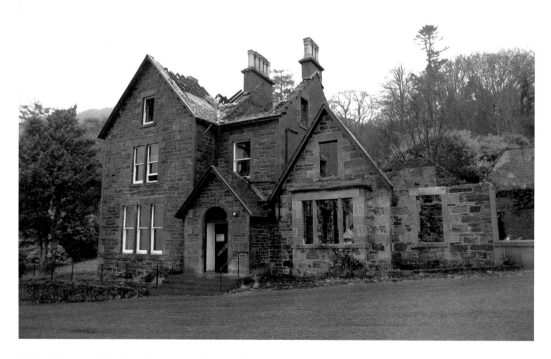

A fire destroyed the hotel at Stromeferry and this is a view of the remains not long afterwards. Since this was taken the remains have deteriorated further and there has been some demolition. (*Ewan Crawford, 28/12/1994*)

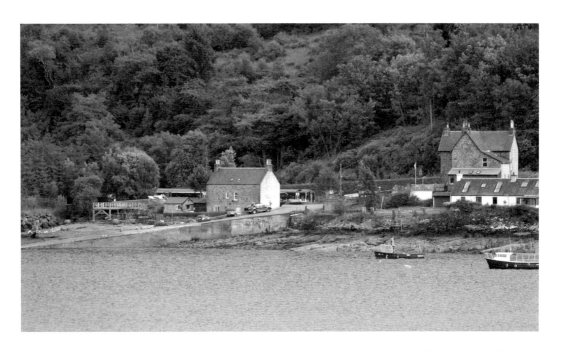

Stromeferry station, as seen across tidal Loch Carron, from Strome Castle on the north bank. 158705 has just called on its way to Inverness with the 1715 from Kyle. In front of the station is the slipway of the old car ferry, replaced by the A-road from Strathcarron in the late 1960s. (*Mark Bartlett, 10/07/2012*)

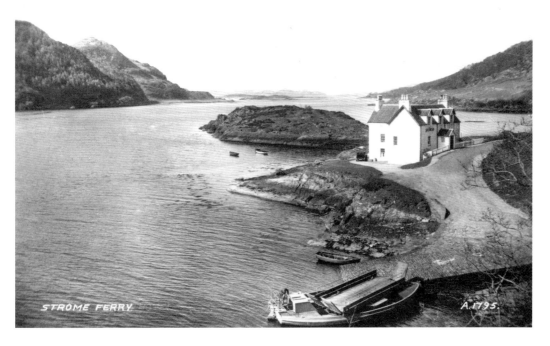

STROME FERRY

A.1795.

The old ferry is seen at the north bank slipway with the hotel building beyond. The narrowness of the loch here and its rocky nature can be seen. Stromeferry was not a very good place for a port for steamers to Portree and Lewis. (*Valentine's postcard*)

Strathpeffer Branch

Strathpeffer was developed as a spa town due to the sulphurous springs discovered there in the late eighteenth century. A pump room opened in 1819 and hotels and a pavilion followed. Due to the deviation of the Skye railway via Raven's Rock, Strathpeffer was served by an inconvenient station up a hill and nearly two miles distant. As a result, the coach to Dingwall was more popular. After the death of MacKenzie of Coul in 1868, opposition to a railway in Strathpeffer subsided and an Act was passed on 28 July 1884 for a 2.5-mile HR branch, which opened on 3 June 1885.

The former Strathpeffer station was renamed Achterneed. The dock platform at Dingwall, which had opened with the Skye line, was used for the Strathpeffer branch. Further hotels followed: the Ben Wyvis in 1887 and the HR's own Highland in 1911. Services increased from around five return trains to ten, with additional Inverness excursions and the Strathpeffer Spa Express which ran on a Tuesday from Aviemore, stopping only at Dingwall, to Strathpeffer and returned to Inverness in the evening. Services were well advertised and the spa was promoted by the HR.

The express was withdrawn when the First World War started and, as popularity of the spa waned, passenger services declined, ceasing on 23 February 1946. Complete closure came on 26 March 1951. The station buildings survive, having been renovated in the 1980s, and now house the Highland Museum of Childhood and shops. Trains may return; the Strathpeffer Spa Railway Association plans to re-open the branch.

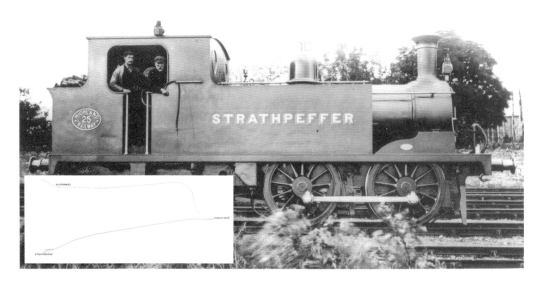

This was the third locomotive to be called *Strathpeffer* and was to be based at Dingwall as the Strathpeffer branch locomotive from its building in 1905 until 1930. After operating the Dornoch branch for some years, it was withdrawn in 1956. (*Ewan Crawford Collection*)

Strathpeffer
A busy Strathpeffer station seen from the buffer stop end. The stationmaster's house is off to the right and the goods yard is beyond the building to the left. (*Ewan Crawford Collection*)

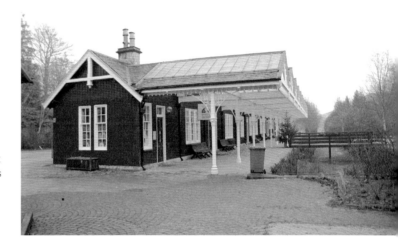

The station building has survived the many years since the line closed in 1951 intact. By the 1970s it was in poor shape but was renovated in the 1980s. It is in fine condition and certainly worth a visit. (*Ewan Crawford, 1998*)

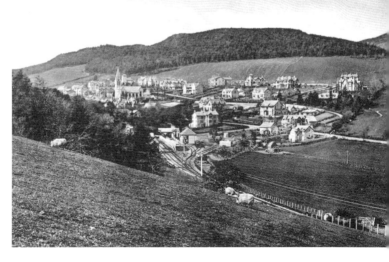

The station throat and fan of railways is seen in this view from the east. The signal box can be seen on the left and goods shed on the right. (*W. R. & S. Postcard*)

The same view is difficult today due to tree growth; this shows the east end of the platform. (*Ewan Crawford, 1998*)

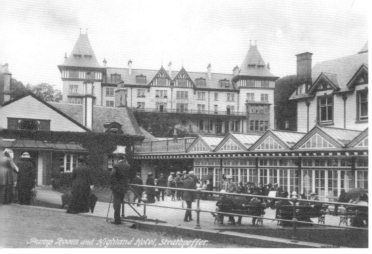

The HR was fairly slow to open its hotel but when it did it was an impressive building. The 1911 hotel is seen rising above the pumproom buildings in the foreground. (*Ewan Crawford Collection*)

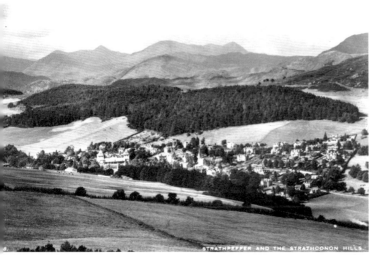

So large is the hotel that it can be picked out to the left in this view of the town. There is an interesting wisp of steam rising to the bottom right, unless that's artistic license by the photograph developer! (*J. B. White Ltd postcard*)

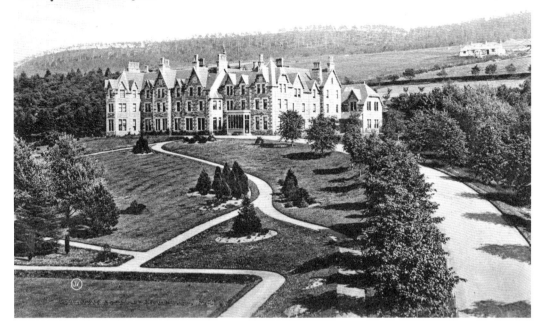

The Ben Wyvis Hotel opened in 1887, with large grounds. (*Ewan Crawford Collection*)

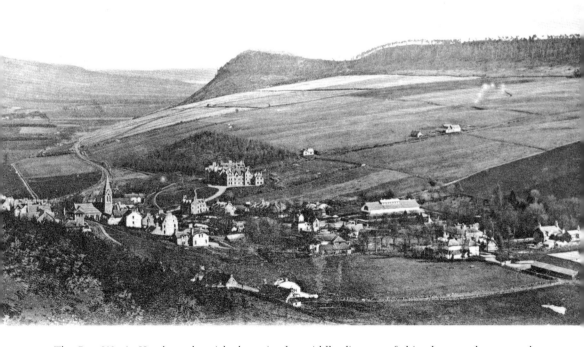

The Ben Wyvis Hotel can be picked out in the middle distance of this photograph, as can the railway approaching the terminus, to the left, and Knockfarrel in the distance. (*Valentines Series*)

Extension to Kyle

The HR's extension to Kyle received its Act on 29 June 1893. The route chosen demanded heavy engineering works throughout. For the approach to Kyle alone, 100,000 cubic yards of rock were blasted to prepare for the site of the shed, cattle dock, sidings and platforms. Before opening, the name Kyle of Lochalsh was chosen for the terminus, although the location was and still is known as Kyle. The line opened on 2 November 1897. The pier at Stromeferry closed and ferry services transferred to Kyle.

The portion of line between Stromeferry and Kyle is particularly attractive, with sea views and inlets passing under the line in numerous locations. The town of Plockton, one of the largest on the Kyle line, was finally served by the railway and was no longer reliant on ferry services to connect with the outside world. Kyle was to develop, with HR assistance, into a town, having formerly been only an inn and a few houses by the Kyleakin ferry landing.

In 1880, upon completion of the Callander & Oban Railway, traffic was lost by the Skye line. When the West Highland Railway opened to Fort William in 1894 there was little immediate threat to traffic but an extension to the open sea was likely. Extension to Kyle became an important issue. A Royal Commission of 1889 considered several railways in the Highlands which could receive financial assistance. These were Garve to Ullapool, Achnasheen to Aultbea, Banavie to Mallaig, Culrain to Lochinver, Lairg to Loch Laxford and Stromeferry to Kyle. Amid much politicking, the Mallaig and Kyle extensions were built, with the government providing £45,000 of the total cost of £200,000 for the latter (£135,000 for the railway, £65,000 for the pier).

The original Dingwall & Skye Bill gave permission to purchase the Kyle ferry and this finally came to fruition. The HR built a pier at Kyleakin and leased the ferry operation to private individuals.

Extra lines were laid to the Admiralty pier at Kyle in the First World War and further sidings were laid at Duirinish during the Second World War. The turntable at Kyle was enlarged as larger locomotives were introduced. In many respects little changed until, in 1973, the Stornoway boat, the *Loch Seaforth*, was withdrawn and a new service started to Stornoway from Ullapool. In 1975 the Portree mailboat ceased and only the Kyle to Kyleakin ferry remained until the Skye Bridge opened in 1995. Since then the pier has seen use for transportation of timber and wind turbines and is visited by naval vessels and cruise ships. The quaysides no longer belong to the railway and the goods sidings have been lifted but the station building is renovated as required and remains in good condition. Some quayside lines remain embedded in concrete, as do two pierhead turntables.

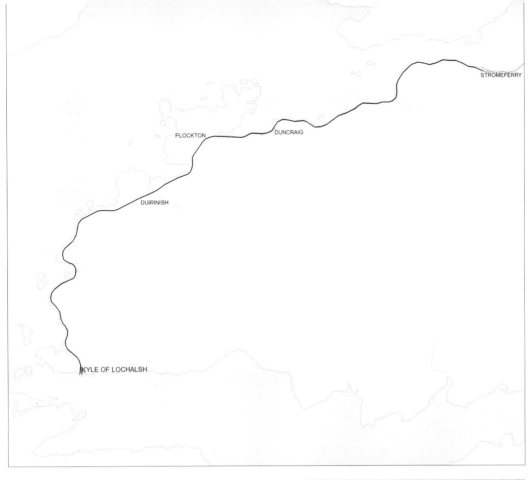

The ticket window at Plockton, seen during renovation of the station building, from the staff side of the window. (*Ewan Crawford, 28/09/2009*)

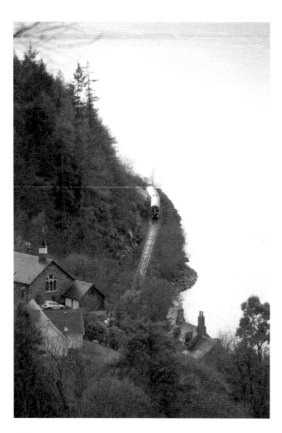

A 158 heads west from Stromeferry. The embankment here has required stabilisation on a number of occasions, with the old cattle loading dock at Kyle sometimes being used as a loading point for boulders. (*Ewan Crawford, 23/11/2013*)

Just east of Portchullin, 158708 heads east with a service for Inverness. (*Ewan Crawford, 01/10/2009*)

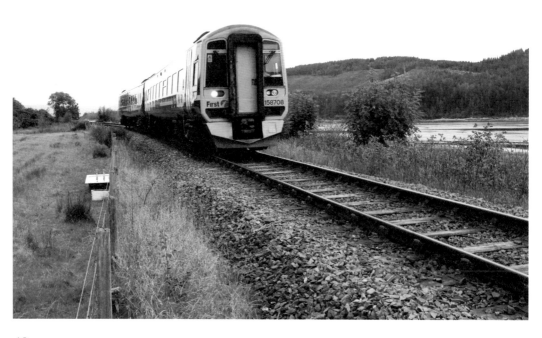

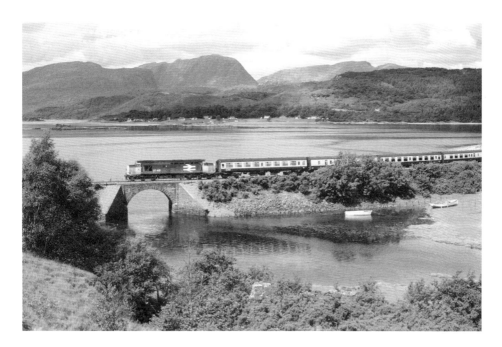

Fernaig Bay

37415 passes Fernaig with the 1110 Inverness to Kyle service. Readers may be familiar with *37s in the Highlands* by Roger Siviter. Several of Graham Roose's photographs feature in that book and date from a trip made to the Kyle line with Roger. Graham recalls, 'We had a fantastic week in the Highlands back in the summer of 1988. We went to Wick and Thurso and visited the line from Inverness to Aberdeen as well.' (*Graham Roose, 23/07/1988*)

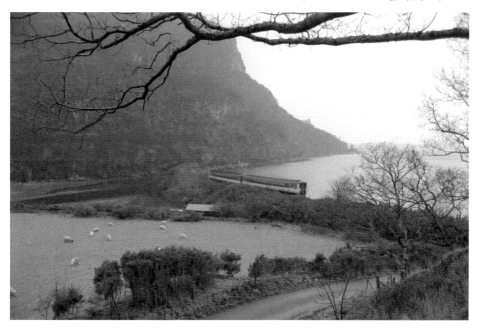

156446 takes an afternoon Kyle–Inverness east over Fernaig bridge on the approach to Portachullin. (*Ewan Crawford, 28/12/1994*)

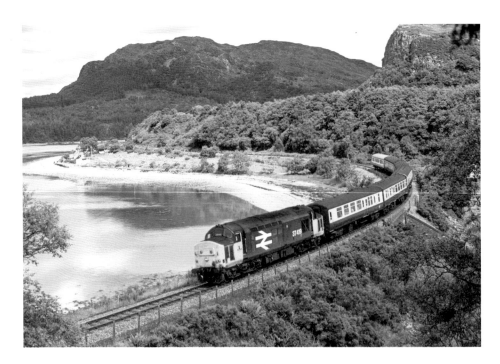

37419 crosses Fernaig bridge with the 1010 Inverness to Kyle service. Stromeferry is beyond the narrows formed by Bad a Chreamha on the left and Creag Mhaol on the right in the background. (*Graham Roose, 23/07/1988*)

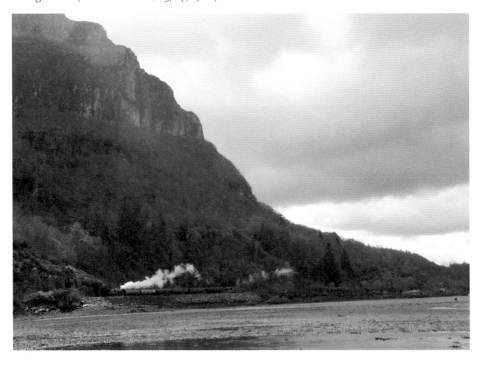

The 'Great Britain VI' passes the crags of Creag an Duilisg with the returning train from Kyle. (*Ewan Crawford, 26/04/2013*)

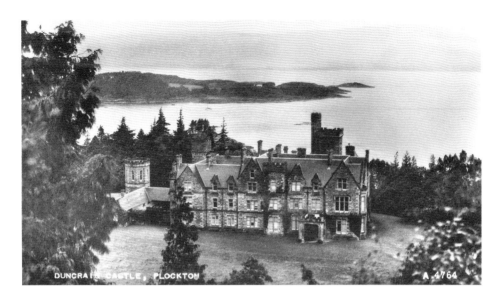

Duncraig

Duncraig Castle was built by Sir Alexander Matheson in 1866, on a large estate he bought after returning rich from China at the age of 36. The site looks out over Loch Carron and is a few miles west of the ancestral seat of the Mathesons at Attadale. The house was to be served by a private station on the Dingwall & Skye Railway had it been built throughout to Kyle and, indeed, it was to be served by the Kyle Extension with a station close to a deep cutting between the house and the sea. (*Valentine's Series postcard*)

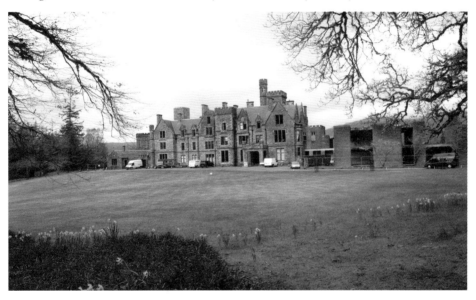

In 1928 the house became the home of Sir Daniel Hamilton; in the Second World War it was a hospital and was afterwards donated to the local council, becoming a boarding school for girls until 1989. After being vacant, and used in filming of *Hamish MacBeth*, it became home to the Dobson family in 2003 before changing hands again more recently. The house is now being renovated, with the unattractive extension at the east end being removed, and will offer accommodation again in 2015. (*Ewan Crawford, 25/04/2013*)

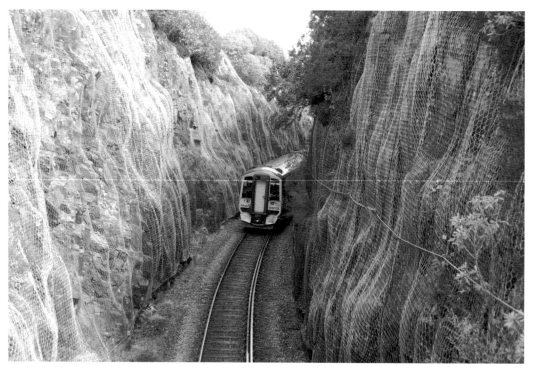

Protective netting now covers the faces of the deep cutting behind Duncraig Castle. 158709 is seen passing east. (*Ewan Crawford, 25/04/2013*)

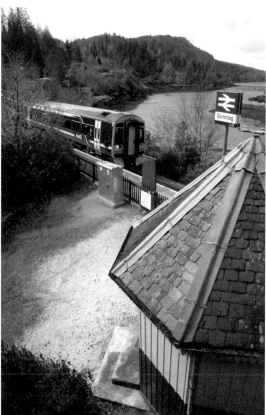

Duncraig opened as a private station with the Kyle extension. It became a public station, called Duncraig Platform, in 1949. 'Platform' was dropped in 1962 and it closed in 1964. However it operated as an unadvertised halt from 1965 until being included on the timetable again in 1976. (*Ewan Crawford, 25/04/2013*)

Duncraig is seen here in the 1990s. At the time I was impressed by the survival of the waiting shelter, although some attention was required. (*Ewan Crawford, 28/12/1994*)

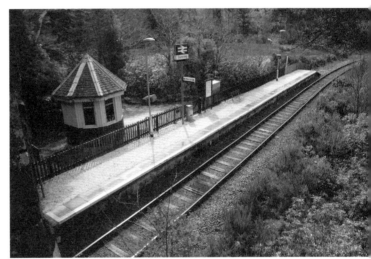

The shelter has received that attention. Superficially not much appears to have changed in 19 years, other than windows being installed in the shelter. But look more closely and you'll see that the platform has been raised, new lighting installed, all signage replaced, timetables displayed, and seating and a bin placed on the platform. The shelter and platform now provide a very nice place to wait for a train. (*Ewan Crawford, 25/04/2013*)

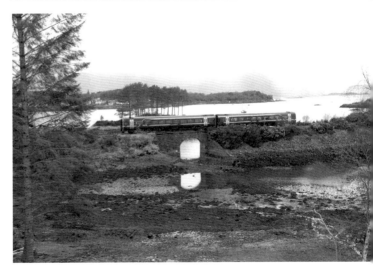

158716 crosses the bridge west of Duncraig station with a train for Inverness. (*Ewan Crawford, 26/04/2013*)

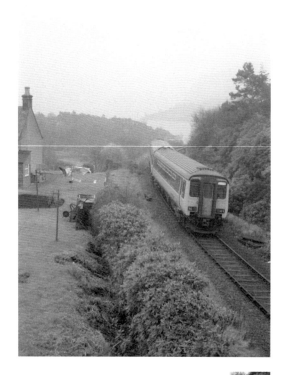

A 156, with no number on display, heads east from Plockton station with an Inverness train. (*Ewan Crawford, 1991*)

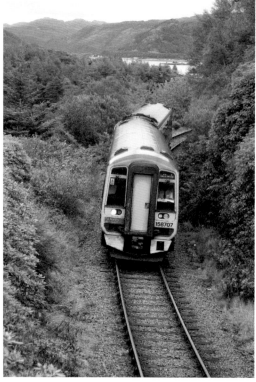

The 1101 Inverness–Kyle of Lochalsh briefly leaves the south shore of Loch Carron as it slows for the stop at Plockton. (*John Furnevel, 29/09/2009*)

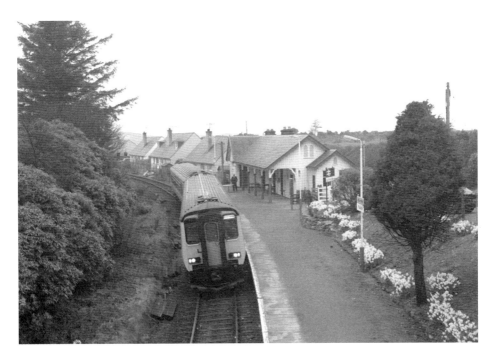

Plockton
Plockton retains its station building in fine HR style. Despite appearances, this was never a two-platform station. An unlabelled 156 leaves the station. (*Ewan Crawford, 1991*)

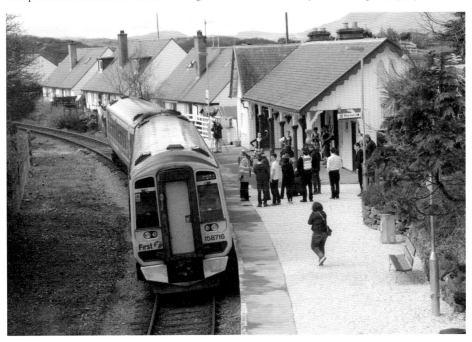

The station has been adopted by Plockton High School and the media turned out on the day of the official adoption. Passengers on board 158716 must have wondered why they were being treated to Highland dancing. (*Ewan Crawford, 26/04/2013*)

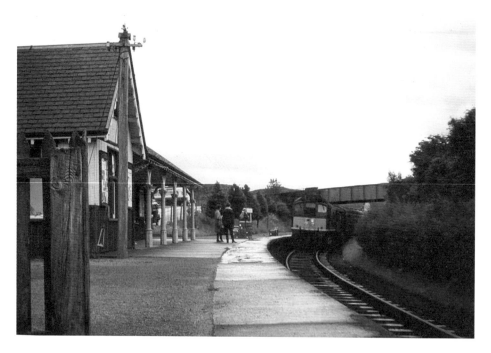

A Kyle-bound train enters Plockton Station behind a Type 2. A number of boxes await loading onto the train. (*John Robin, 07/1970*)

The station seen from a similar perspective. Accommodation ('The Bunkhouse') built in imitation of a signalbox now stands to the right. Off to the left was a goods shed, removed by the 1950s. (*Ewan Crawford, 28/09/2009*)

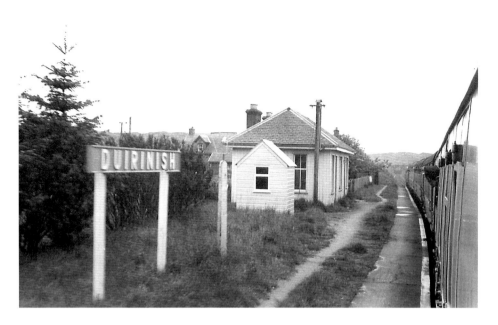

Duirinish

Duirnish has had an assortment of buildings over the years, with the main building seen here surviving from opening into the 1970s. The footpath on the platform suggests this is not the busiest of stations. (*Tony Harden Collection*)

The replacement modest accommodation seen here has survived to the present day. At the time it sported a rather fancy lamp but, I regret, not any more. There's a row of railway cottages seen beyond the station building. Duirinish had a signal box and extra sidings from 1940 to 1945 in connection with wartime traffic and closed to goods in 1954. (*Ewan Crawford, 03/01/1989*)

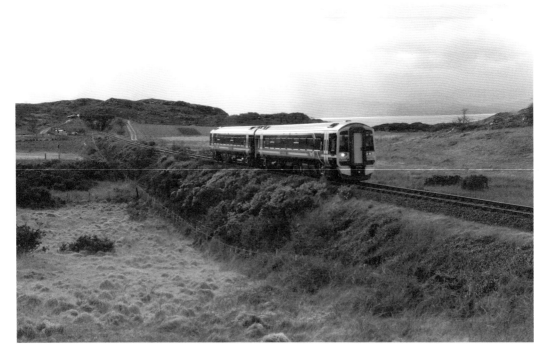

158710 passes Drumbuie and approaches Duirinish from Kyle. (*Ewan Crawford, 25/04/2013*)

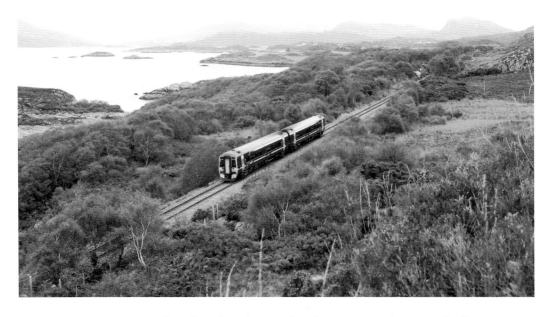

158720 heads east to Duirinish with Loch Kishorn and Loch Carron stretching into the distance. (*Ewan Crawford, 01/10/2009*)

The Cuillins on Skye form the backdrop to this view of 158720 approaching Duirinish from Kyle. (*Ewan Crawford, 01/10/2009*)

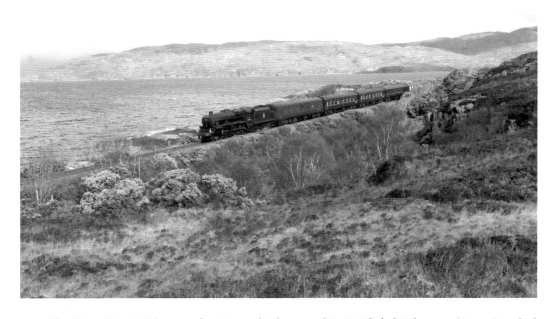

The 'Great Britain VI' approaches Portnacloich, west of Duirinish, behind 45407. (*Ewan Crawford, 26/04/2013*)

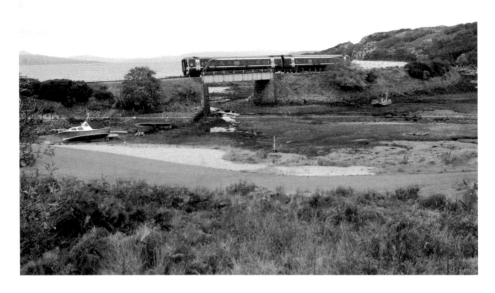

The morning service from Inverness passes south through Erbusaig with only a short distance left to reach Kyle of Lochalsh. The train came through the narrow cleft in the cliff above the right hand side of the right carriage. There are signs of recent embankment stengthening works. The view looks towards the Crowlin Islands. (*Ewan Crawford, 01/10/2009*)

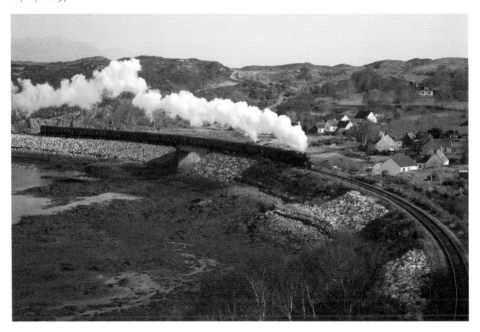

K4 61994 *The Great Marquess* rounds the curve at Erbusaig near Kyle of Lochalsh with the 'Great Britain III' on 12 April. (*John Gray, 12/04/2010*)

Badicaul is one of the
classic viewpoints of the
Kyle line, not far from Kyle.
These three views illustrate
the location. 37416 passes
Badicaul with the 1128
ex Kyle. (*Graham Roose,
23/07/1988*)

The sea is improbably blue
as 37408 passes Badicaul
on the approach to Kyle.
(*Ewan Crawford Collection,
06/07/1991*)

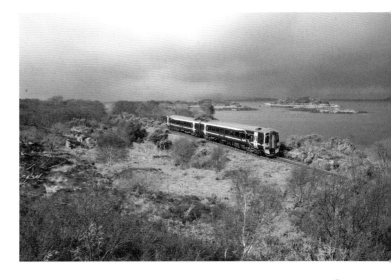

At a different time of year
and under a threatening
sky, 158709 is close to
journey's end heading
for Kyle. (*Ewan Crawford,
25/04/2013*)

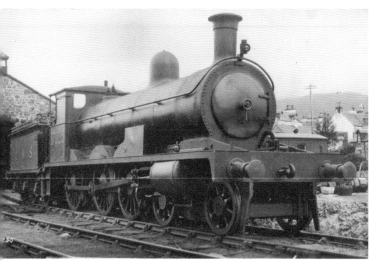

Kyle Shed
This postcard shows a locomotive at Kyle shed. It came with a remarkable set of notes on the rear side. Rather than transcribe the notes, the rear side can be seen below. Sadly, the name of the thorough writer is not known. (*Railway Photographs postcard*)

37416 is about to pass the site of Kyle shed. The building was against the wall seen to the right of the track, and the turntable out of shot to the right. (*Ewan Crawford, 03/01/1989*)

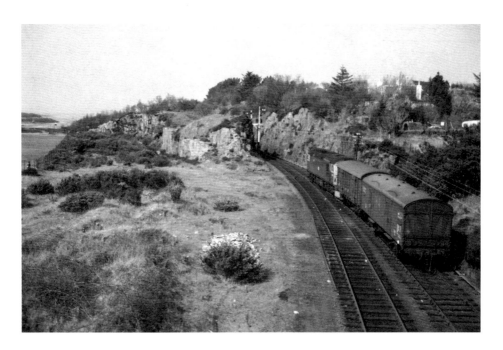

Although the shed closed in 1962 the site of the turntable, to the left of the cutting, could still be clearly seen by the time of this photograph. (*Ewan Crawford Collection, 06/04/1974*)

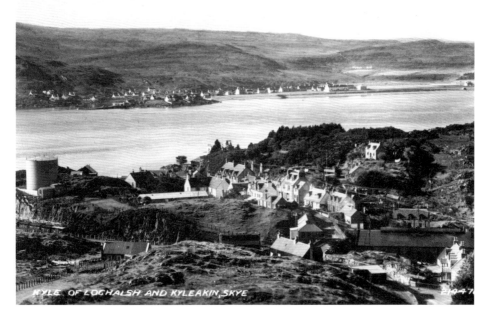

At first glance the railway does not appear to feature in this postcard view of Kyle. To the right is the shed, moving left is a signal gantry and then a series of trucks by the cattle dock on the left. The road seen travelling from bottom right into the village is Main Street, the original road into Kyle. The A87 from Balmacara to Kyle is a newer construction although the railway must have foreseen its construction as the large bridge across the station opened with the line. Kyleakin, on Skye, can be seen across the water. (*Valentine's postcard*)

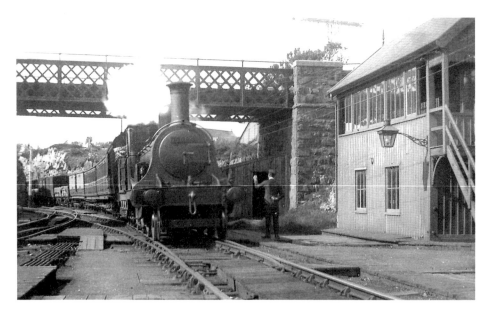

Kyle
A Skye Bogie enters Kyle with a mixed train from Inverness in 1926. Kyle box opened with the line in 1897 and closed in 1984 on introduction of RETB to the line. (*Tony Harden Collection*)

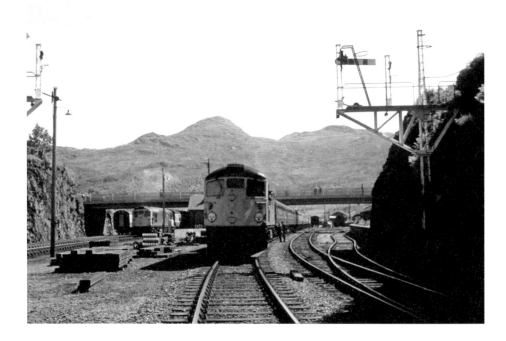

5345 and 5344 head a rail tour train, and 5343 is shunting on the left hand side. (*Stuart Rankin, 19/06/1971*)

The box remained as a bothy for a number of years but was essentially out of use when seen here ten years after closure. (*Ewan Crawford, 28/12/1994*)

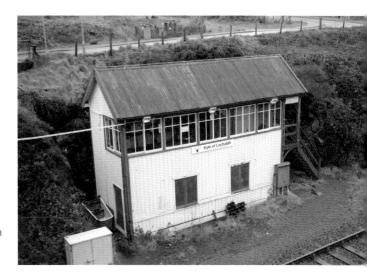

Kyle plays host to the Royal Scotsman in the summer months. Here 47804 is seen rounding its train after arrival at the terminus. The locomotive backs the train down towards the buffer to maximise the number of carriages served by the platform. (*Ewan Crawford, 29 September 2009*)

One signalpost remains at Kyle today; ignominiously, it supports a stop sign only. It can be seen to the left of the second carriage of 'The Royal Scotsman'. The signal box has been renovated and returned to its original appearance. The signal box is now holiday accommodation and has public access and a model railway. (*Ewan Crawford, 27/04/2013*)

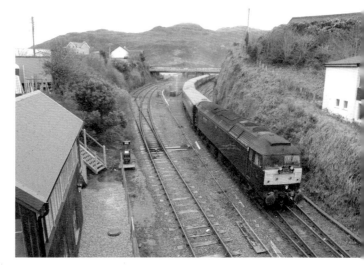

On the tail of an incoming service is an ex-GWR coach restored in chocolate and cream and being used as an observation coach. (*John McIntyre, 04/1979*)

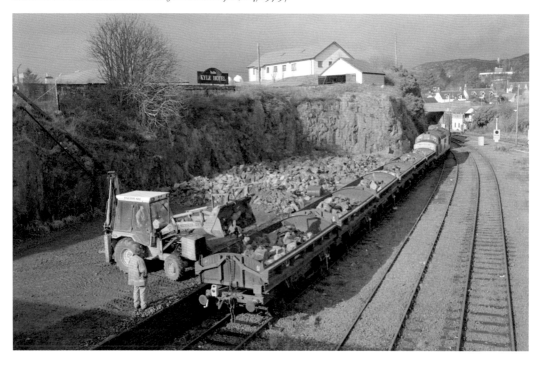

After winter damage to the line's embankment at Stromeferry, rubble is loaded at the former cattle dock. (*Ewan Crawford, 1995*)

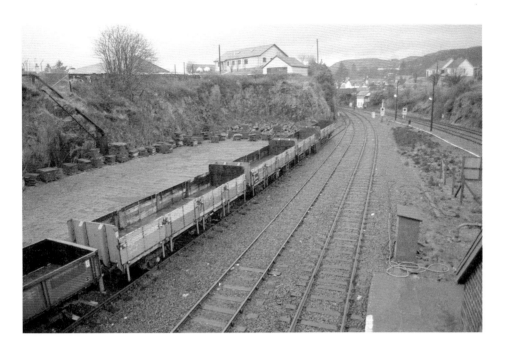

Caithness flagstone for the 'Kyle Prospect' (redevelopment of the waterfront to the west of the station) is unloaded at the former cattle dock. (*Ewan Crawford, 21/03/1997*)

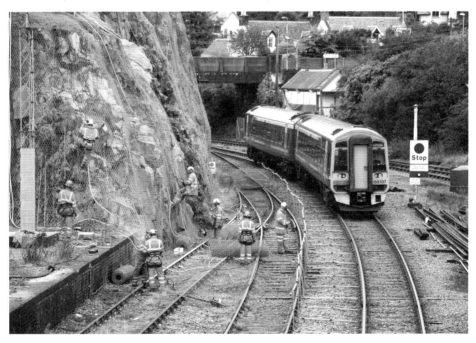

This was part of the extensive safety work carried out during September and October 2009 on rock faces at the western end of the Kyle line, resulting in temporary closures to both road and rail links during the period. This scene shows such work in progress just outside Kyle of Lochalsh station as 158707 leaves with the 1435 service for Inverness. The old signalpost can be seen just to the right of the train. (*John Furnevel, 29/09/2009*)

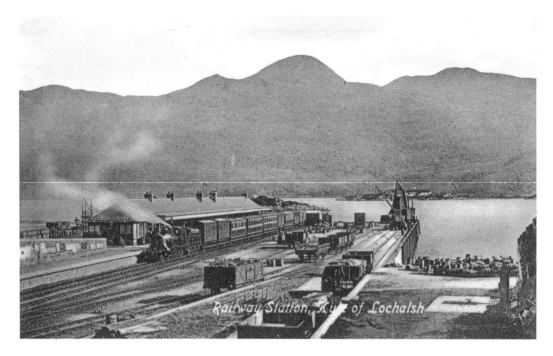

Kyle of Lochalsh is a dramatic location for a terminus. It is a seaside station built on a pier with an excellent view of Beinn Na Caillich across the water on Skye. Kyle is laid out in a much more generous way than Stromeferry was, having three pier faces with lines. A mixed train waits at Kyle station behind a Skye Bogie, possibly around 1919. (*Valentine's Series postcard*)

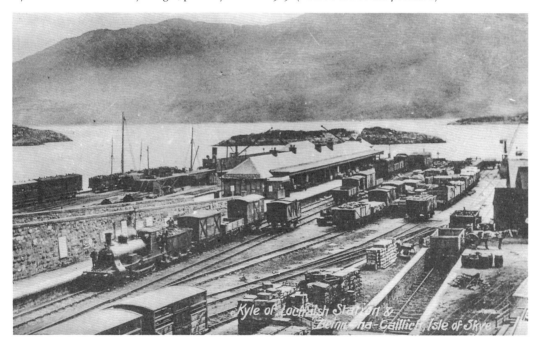

This is probably one of a series of photographs by Duncan Macpherson from around 1920. A Skye Bogie is in charge of a short goods train. (*Ewan Crawford Collection*)

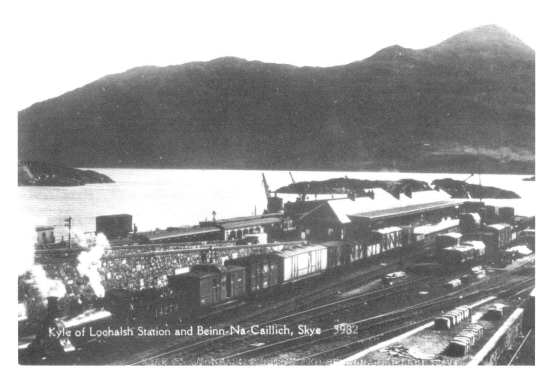

Kyle of Lochalsh Station and Beinn-Na-Caillich, Skye 3982

A Skye Bogie with number 14279, so post 1923, shunts a goods train at Kyle. There is a brake van directly behind the engine. The rolling stock in platform 2 is noticably more modern than the previous photographs. (*Ewan Crawford Collection*)

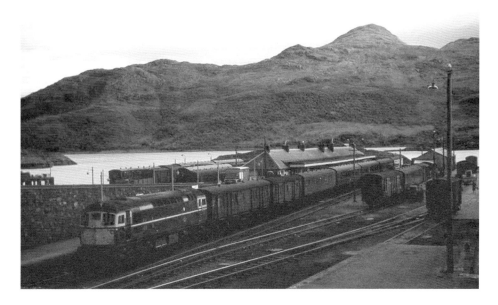

Jumping forward in time, D5334 waits at Kyle of Lochalsh with a mixed train. (*John Robin, 17/08/1965*)

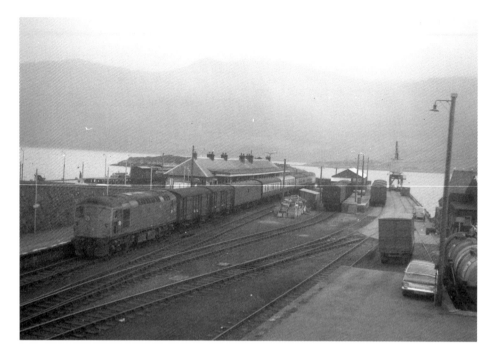

An Inverness train prepares to leave Kyle in 1969, when freight was an important part of the railway's role and the steamer from Mallaig still called at the railway pier en route to Stornoway. (*David Spaven, 1969*)

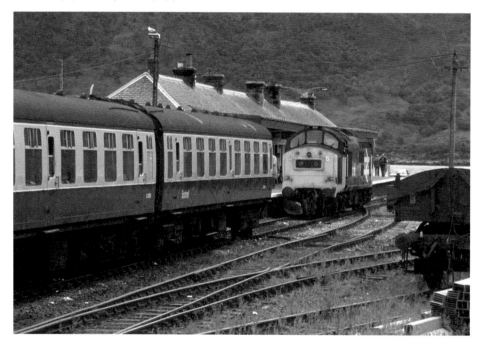

A 37 rounds its train when the station's goods sidings were still intact but the only wagons present are for maintenance of the line; this is not surprising as the line effectively closed to freight in 1983. (*Ewan Crawford Collection, possibly 1986*)

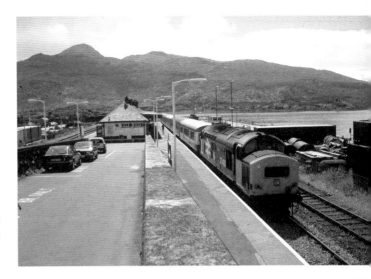

On a blisteringly hot day in 1991, 37408 *Loch Rannoch* waits at platform 1 with the carriages and converted DMU stock. (*Ewan Crawford, 1991*)

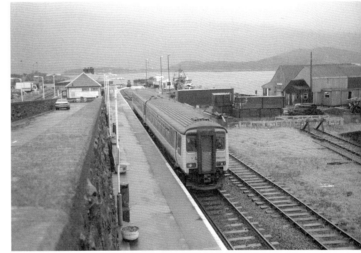

On a rather wetter day, 156446 arrives at Kyle. The buildings to the right were to be swept away by the 'Kyle Prospect' development. (*Ewan Crawford, 27/12/1994*)

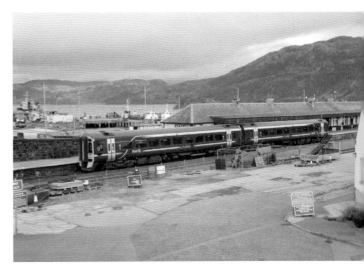

158711 moves out of platform 1 en route to platform 2 not long after arriving from Inverness. This is in preparation for the arrival of 'The Royal Scotsman', which will need platform 1 in order for the locomotive to round its train. (*Ewan Crawford, (26/04/2013*)

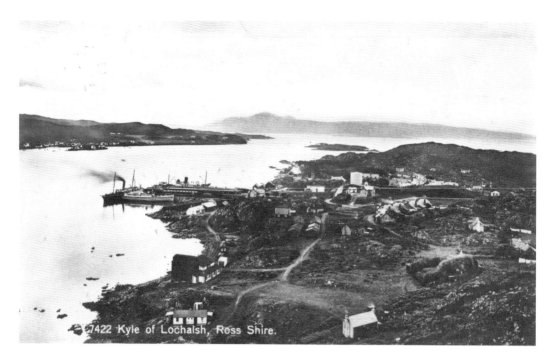

A group of steamers cluster at Kyle's pier in this postcard view. Carriages are stored in the easternmost sidings but the Admiralty pier has not yet been built. The locomotive shed is on the right hand margin of the photograph. (*Ewan Crawford Collection*)

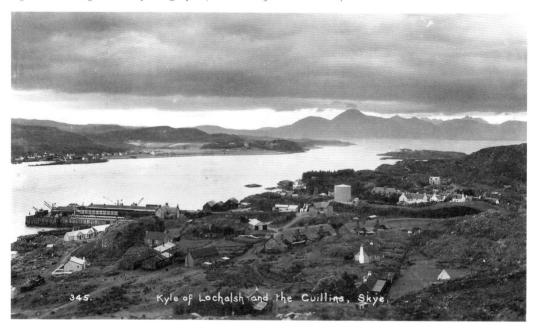

In this view, goods wagons are stored on the easternmost pier. Some form of screen seems to have been erected between the passenger platform 2 and the loading bank on the pier; this can also be seen, more indistinctly, in the above photograph. The A87 has not yet been built. (*Ewan Crawford Collection*)

The goods yard on the east part of the pier is seen to good effect in this view. The lines are clearly still busy with goods traffic. (*Ewan Crawford Collection, 07/07/1962*)

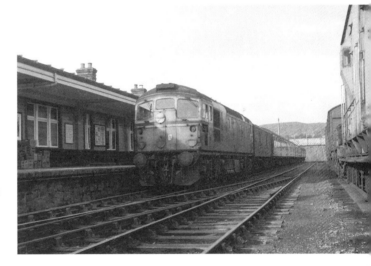

D5335 arrives at platform 2. At this time it was still possible for a locomotive to round its train in platform 2. (*Graham Roose, 20/10/1966*)

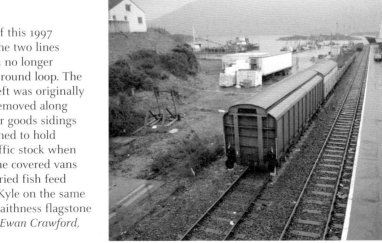

By the time of this 1997 photograph the two lines by platform 2 no longer constituted a round loop. The track to the left was originally going to be removed along with the other goods sidings but was retained to hold excursion traffic stock when not in use. The covered vans seen here carried fish feed and came to Kyle on the same train as the Caithness flagstone seen earlier. (*Ewan Crawford, 21/03/1997*)

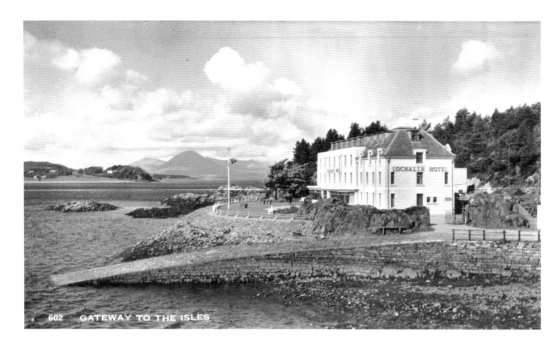

The HR's station hotel at Kyle was rebuilt in 1934 and the resulting building is seen here. The hotel opened with the line but may have been an earlier building modified from a lodge into a hotel. The hotel is located on the far side of the slipway from the station and remains open today. (*Kyle Pharmacy postcard*)

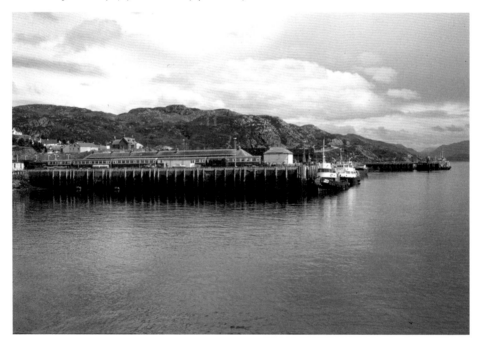

A car ferry was introduced for the Kyle–Kyleakin crossing in 1928. This photograph was taken from one of its Caledonian MacBrayne successors and shows the Kyle station pier. (*Ewan Crawford, 1991*)

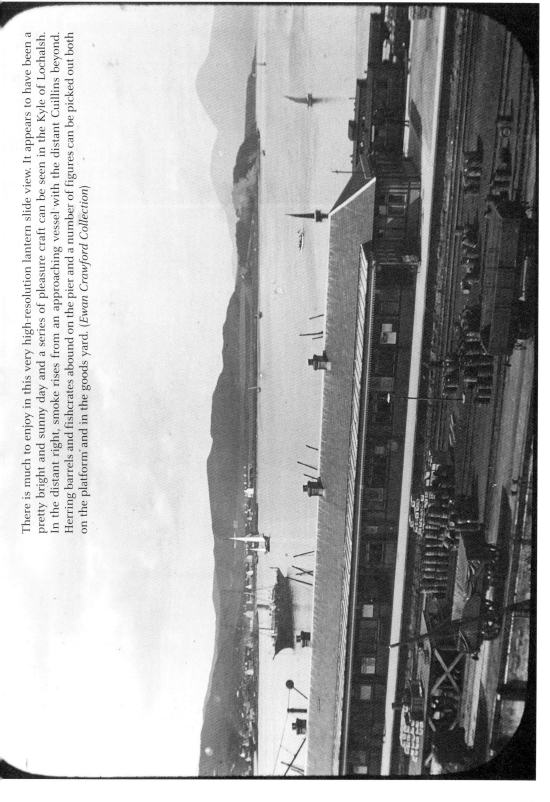

There is much to enjoy in this very high-resolution lantern slide view. It appears to have been a pretty bright and sunny day and a series of pleasure craft can be seen in the Kyle of Lochalsh. In the distant right, smoke rises from an approaching vessel with the distant Cuillins beyond. Herring barrels and fishcrates abound on the pier and a number of figures can be picked out both on the platform and in the goods yard. (*Ewan Crawford Collection*)

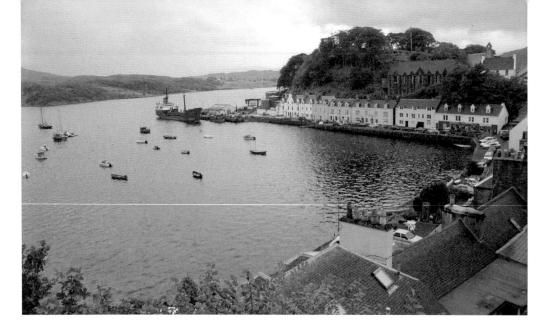

The railway was built to serve Skye and Lewis and perhaps the reader will forgive me this view of Portree, on the Isle of Skye. The red vessel is one of the Glenlight Shipping Ltd lighters, successors to the Clyde puffer tradition. The company finally disappeared around 1994. (*Ewan Crawford, 08/1993*)

Acknowledgements

Louis Archard, Mark Bartlett, Beth Crawford, John Furnevel, Mike Gibb, John Gray, Tony Harden, Colin Miller, Bruce McCartney, John McIntyre, Stuart Rankin, John Robin, Graham Roose and David Spaven.

Links

RailScot – my own site, with histories and photographs of Scottish Railways (www.railbrit.co.uk)

Friends of the Kyle Line, incorporating the Kyle Station Museum (www.kylerailway.co.uk)

Highland Railway Society (www.hrsoc.org.uk)

Scottish Railway Preservation Society – has the largest collection of railway locomotives, carriages, wagons, equipment, artefacts and documents outside the NRM (www.srps.org.uk)

ScotRail – the operator of the trains on the Kyle Line; book your ticket here (www.scotrail.co.uk)

Further reading (a very small selection)

The Skye Railway, John Thomas ISBN 0-946537-62-3

Rails to Kyle of Lochalsh, David McConnell ISBN 0-85361-513-6

The Kyle Line, Tom Weir ISBN 0-95019-441-7

37s in the Highlands, Roger Siviter ISBN 0-946184-52-6